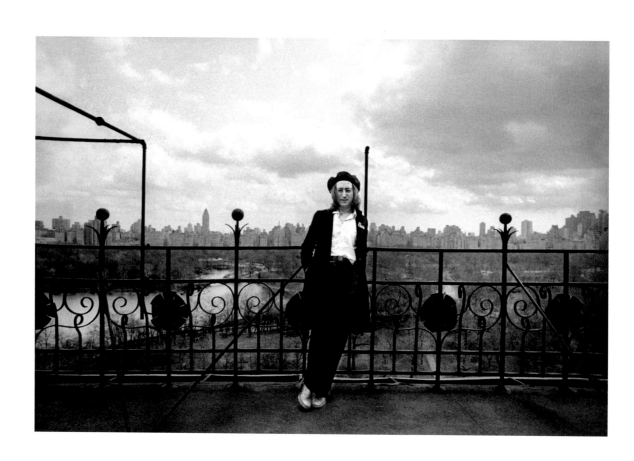

Dream Lovers

JOHN AND YOKO IN NYC

The Photographs of Brian Hamill

ACC ART BOOKS

For my wonderful grandkids, Seychelle and Soren.

... whenever the human race starts to disappoint me I think of these two human gifts, my terrific grandkids. They always make me smile and illuminate my soul.

Also for my brother, Pete.

... thanks for your continued kindness, and generous encouragement, and for your tremendous gift of writing.

Brian Hamill

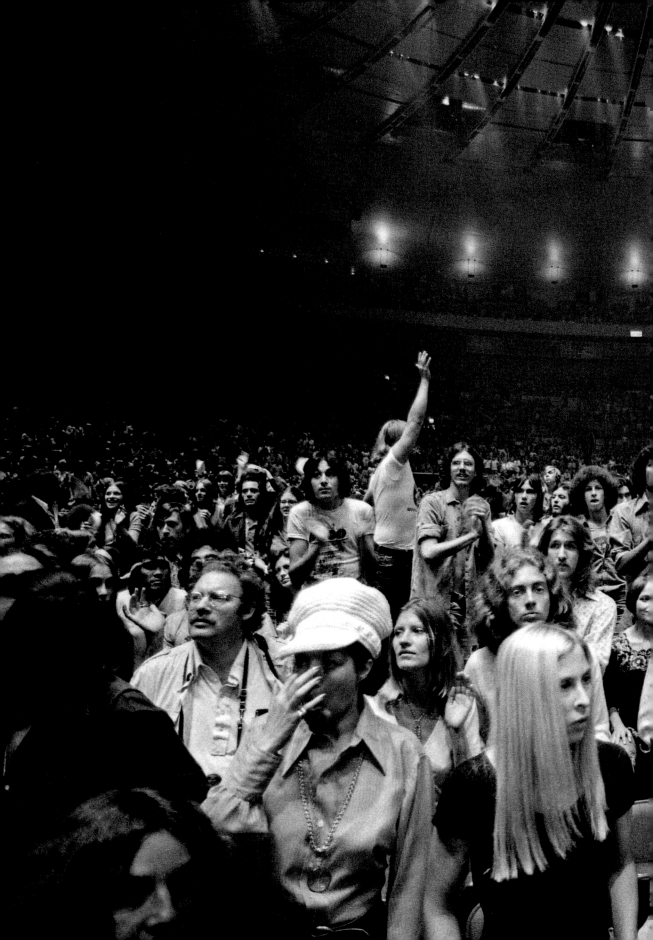

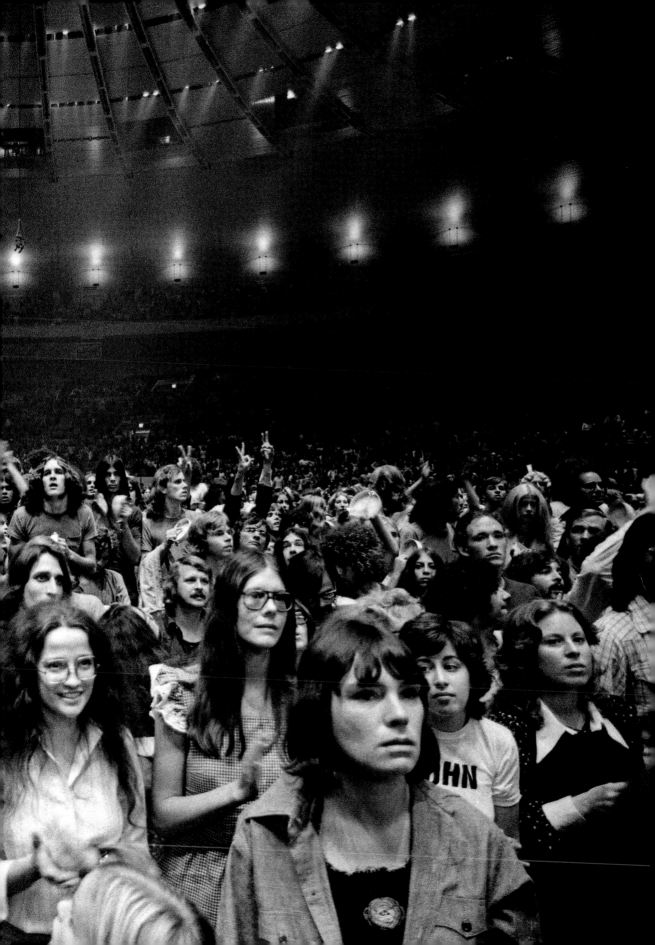

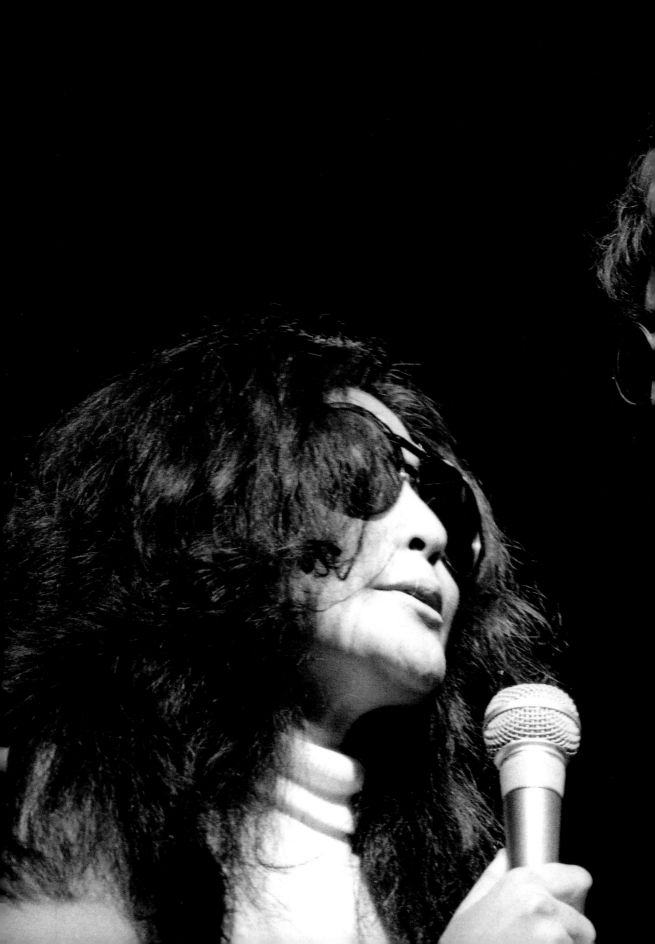

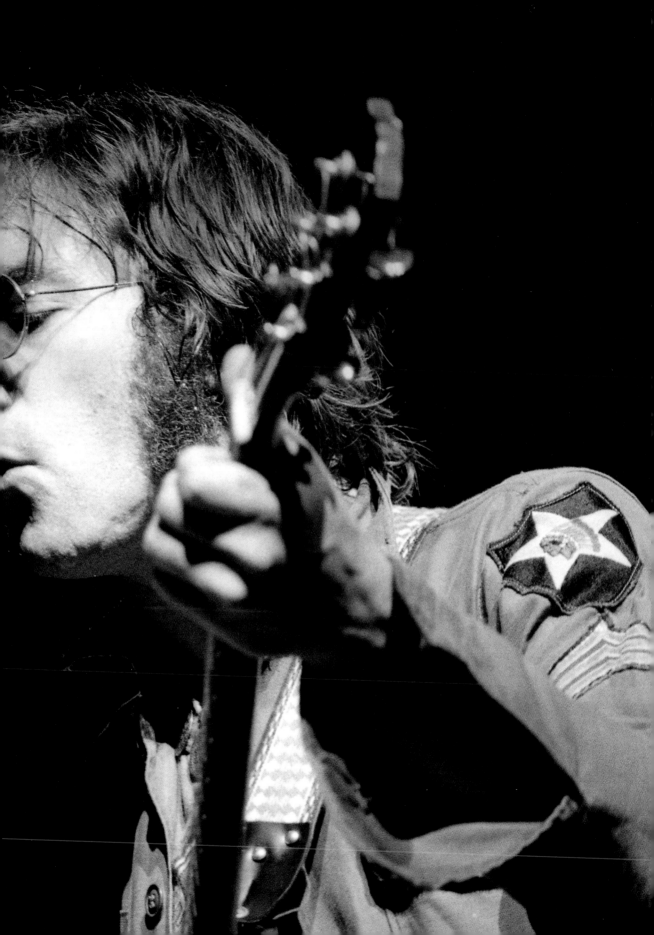

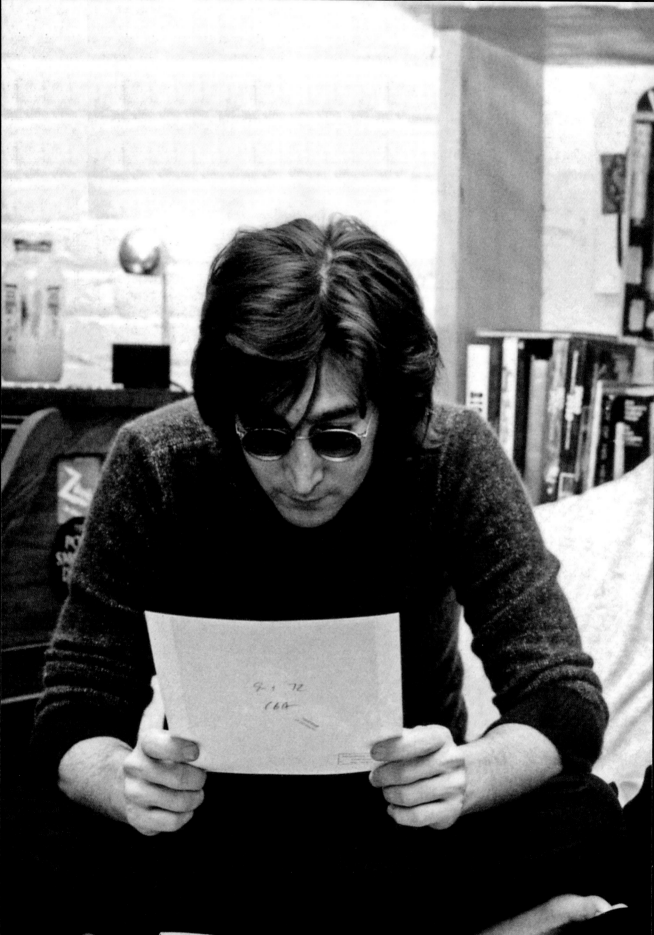

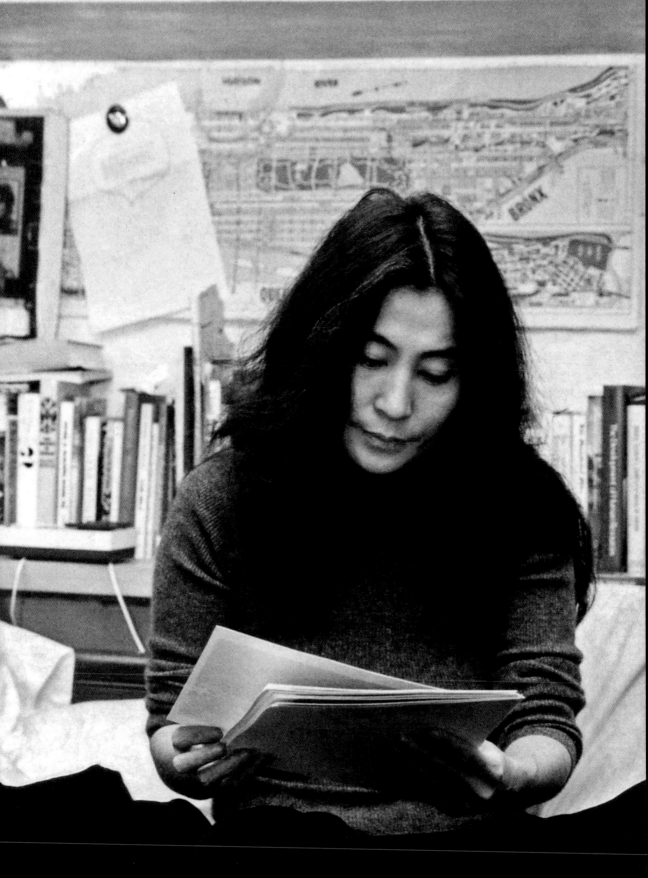

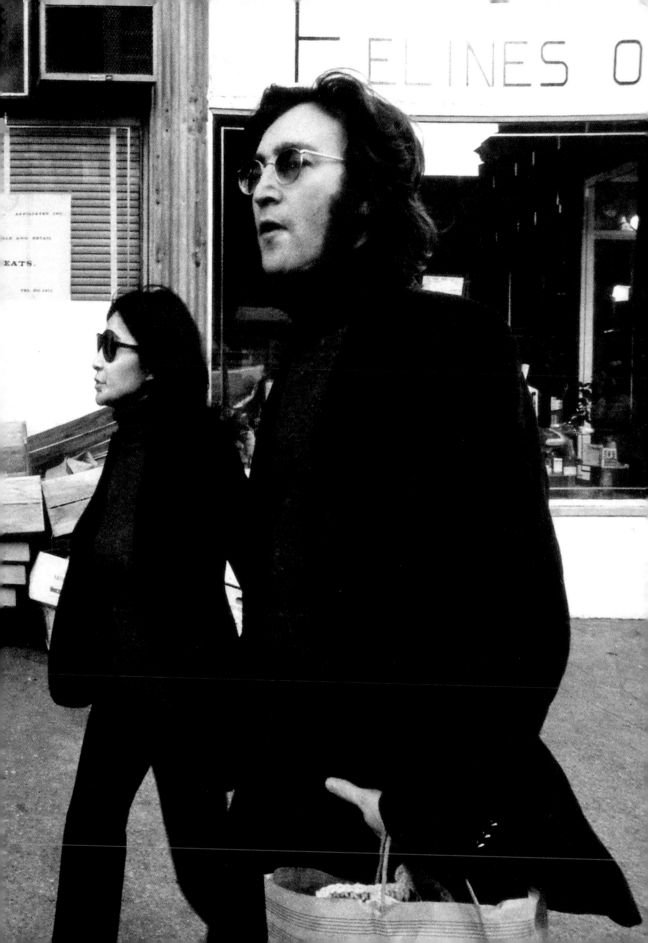

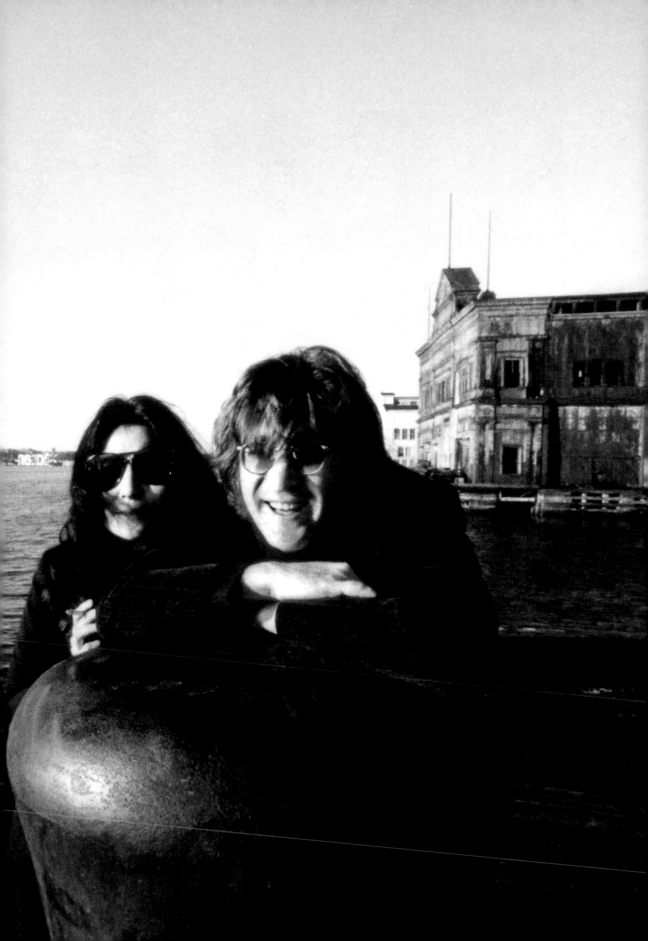

Foreword
Alec Baldwin

If you recall, there was a time, and it does seem a century ago, when a camera was either a delicate and, therefore, expensive item certain people had or there was a ready-to-wear version: easy to use, far cheaper, disposable.

Even with the cheap ones, you nonetheless had to aim the thing, factor in the light and some amateur sense of composition and then send it to the developer, to later receive the four-inch by six-inch proof that you had little to no talent.

Photography involves, and there is no other way to put it, some amount of wizardry.

Today, everyone has a camera in their hand all day long and the bar is so low you can step over it, and we just delete our bad work without a thought. Once upon a time, however, one might be in a studio and be in the presence of a true master. Over the years, I've been photographed by some rather famous artists. Neil Leifer, Annie Leibovitz, Herb Ritts, Greg Gorman, Brigitte Lacombe, Michael Tighe, Matthew Rolston.

In films, a set photographer is a different animal. Less of a star, less king or queen, but a collaborator and a member of a crew. The good ones knew the rule: I'm here to act for one camera, to play to one camera. Don't be in my eyeline when we shoot. Don't make a sound. Shoot the rehearsals whenever possible. Only ask the cast to – literally – pose for shots after the set-up is finished.

Some got it. Some kind of got it. Some nodded and then played some game which told me they didn't actually get it. In the old days, there was a photographer on set for stills many days, most days. Sometimes every day. Now, it's called "specials" and someone shows up for a day or two to cover the principal cast.

In the old days, the still photographer began by assessing the situation. He adapted. He got a sense of people's rhythm. Any good actor wants good stills. The stills from the sets of some of my own films, on the walls of my office (only a precious few in my home), are prized possessions. Me and Marty, Bob, Tony, Meryl, Sean, Tom, Woody, Hunt,

Glengarry, Miami Blues, Mission, It's Complicated, Blue Jasmine, 30 Rock. My life.

On the set of Woody Allen's film *Alice*, with Mia Farrow and William Hurt and Keye Luke, up walks Brian Hamill, the famous stills guy from *Annie Hall*, *Manhattan*, *Raging Bull*, *Arthur*, *Tootsie*, *The Natural*. The fly on the wall for at least six, maybe eight, of the greatest 100 films of the past 50 years. Like a Dead End Kid, his New York DNA oozing out of every pore; I realize James Cagney now has a camera and is shooting stills on the set of the movie.

Hamill is a Hamill, and by that I mean the artistry is the glove on the hand of a pretty tough guy. Middle brother to Pete and Denis – two other planks in the boardwalk of New York life and history.

"I'm gonna take some pic-jiz and I'll be outta y'way," he says. What am I gonna do? This guy shot the iconic photo that became the poster for *Manhattan*. He looks you in the eye. John Lennon sat for him. Shirley MacLaine. Ali let him… follow him around.

John Lennon moved to New York to live that funky, public-private thing that celebrities find there. "Millionaires and whores ridin' in the same cabs," my uncle used to say. Lennon, one of the most famous men in human history, wanted to live as one among many. Of course, he hit it off with Hamill. The guy that flew so high needed some oxygen. Hamill is fresh air. His folio of Lennon images shows Lennon focused, present, but edgy, never relaxed. And why bother? Maybe he was fond of his tension. Did Lennon sit for Hamill just for Hamill's company? Don't rule it out.

"I'm gonna take some pic-jiz and I'll be outta y'way." And then what? Rob a bank? Defend the welterweight title? Rush off to a Broadway opening or a dinner with your many friends, who all admire you and love your friendship, with a gorgeous girl on your arm?

We became pals.

Brian Hamill is a great photographer and a great guy. And a wizard. Have a look.

Why John Lennon Still Matters
Pete Hamill

John Lennon was always a mysterious man.

All artists who matter remain mysterious. John Lennon still matters because as long as his music lives, so does he. Great artists never really die. Just as Frank Sinatra taught a whole generation of men of my generation in the 1940s and 1950s that it was okay to feel real emotions instead of mouthing some of the stupid, silly songs of the 1930s, John Lennon used his mysterious gifts of music and words to ask a generation of the 1960s and 1970s to open their hearts and minds, to "Imagine" a better world where after endless wars human beings might try to "Give Peace a Chance".

I can name half of John Lennon's songs and I am not from his generation. Young people today still sing them. Few artists last from one generation to the next. Sinatra did and he was a singer, not a writer. John Lennon was a singer, a musician, and a writer whose songs are as meaningful today as when he wrote them.

In the working-class world where Lennon grew up, family was everything. You had family, or you didn't. Mothers or fathers were sometimes told to leave and never come back. Some tried to create replacements. Disappointment was frequent.

But sometimes, finding the right knee to sit upon

as a child was all just a matter of luck.

The name "Lennon" is the Anglicized version of O'Leannain (see Ray Coleman's book, *John Winston Lennon, Volume 1 1940-1966*, Sidgwick & Jackson, 1984), a clan strongest in the Galway, Fermanagh and Cork counties of Ireland. And his first name was derived from his paternal grandfather, John Lennon. One of the original John's five sons, Alfred (Freddy) married Julia Stanley, who would give birth to one of the original Beatles in Liverpool, in 1940.

At four-and-a-half years old, John was taught to read and write by his Uncle George, his Aunt Mimi's husband. Every night, George sat John on his knee and read aloud the *Liverpool Echo* newspaper in a rhythmic sing-songy way until the boy could read the words to George.

The words John Lennon learned from his Uncle George became John's weapons and treasures and his shield. He made songs with those words and rhythms. The words helped inspire a 1960s rebel. And so, to me, John Lennon was a secret Irish rebel. His words also overtook the imaginations of young people across the world, uniting them as they dared to be different or marched for peace. His lyrics and music united him with Yoko Ono and together they gave a lasting, magical power to the people who listened to them.

It makes perfect, ironic sense that an artist born amid the horror of war would grow up to write anthems asking for peace, love, and for human beings to try living as one.

In the Liverpool where Lennon was raised, love stories were not simply products of cynical commercial hacks. Details of real-life romances were nobody's business. But in song, Lennon found the freedom to transform love and loss and war into a celebration of life and lasting art.

John Lennon didn't preach so much as he asked the young people of the 1960s and 1970s to make revolution with peace.

In my family, many stories rose from tales told at wakes and weddings. Full of laughter, anxiety, song and relief. Or full of tears or the rare ray of hope in the aftermath of tragedy. There were seven American Hamill kids born to my Irish immigrant parents. Four were gifted with the writer's gene. Two of us had the graphic gene. I was one. Brian was the other. He became the young brother with a camera who captured the timeless images in this book and so many others with his probing lens. He looked at the John Lennon who had become an icon and saw instead a familiar face. He saw a working-class hero like those that built the City of New York. And so when John Lennon came to live in New York, Brian captured him as a

New Yorker, in the joyous images that you will find in this book. On my 85th birthday, this year, as the eldest of our clan, I told my brothers and sister and our children, that our goal in life should be to use whatever skills, talents or gifts we have to leave the world as a better place than we found it.

That way your life will have mattered. As Sinatra's did in a different way. And as John Lennon's still does to this day.

Even though the life of this man of peace ended so senselessly and violently in New York, John Lennon made New York a much better place by living here and walking its streets hand-in-hand with Yoko Ono, as you will see in the photographs of this special volume.

John Lennon still matters because he used his mysterious talents to make something more important than money. Other people he never met were made better human beings by listening to his songs. John Lennon still matters because he left the world a much better place than the war-torn one he was born into.

John Lennon still matters because his songs are as alive today as the day he wrote them.

As alive as every enduring image in these pages.

Drama in the Details
Dana Delany

Looking at Brian Hamill's photographs of John Lennon and Yoko Ono in 1972, they seem as one person. As they walk in Greenwich Village in matching turtlenecks and blazers, hidden behind dark glasses, joined at the hip, they are a united entity. Even the tendrils of their hair entwine into a shady cloudy dream.

At their new modest home on Bank St they are more business partners. Separate, but equal. They look over the contact sheets that Brian shot of what would be their last live concert together. Behind them a map of Manhattan, their adopted city. This is Brian's métier: capturing a moment in time. Even though he is a famous still photographer for movies, there is nothing still about his work. He catches the details of every day interaction. And the drama beneath that.

Three years later, Brian is invited to the iconic Dakota to photograph John Lennon again. When Brian asks how he's been, John replies, "I had a strange year, but all is cool now." Brian lets it lay because that's what you do if you're from Brooklyn and you're a stand-up guy. But you can see it in the photographs. John is alone. Yoko is in another apartment in the building.

John is dressed in a Western shirt and wearing a worn pair of Frye boots. He is thinner and seems, well, there. As if he has nothing to hide, no need to perform. As if the last eighteen months when he was in Los Angeles, separated from Yoko, cleansed him of any drama. John famously called it his "lost weekend." It's been said that Yoko knew he needed it. He is back now and Brian's camera lets us see the guy who only wants to make toasties and sing Marvin Gaye songs.

And then we are up on the roof and the clouds darken once again. It is hard to see the stunning shot of John with the New York skyline and Central Park beyond and not imagine the future. It's all there. The black gothic balustrade of the Dakota, the foreboding sky, the field that would one day be called Strawberry. And John, wearing a rhinestone "Elvis" pin in honor of his teenage idol, smiling politely for the camera.

I met Brian Hamill eight years after this session. I was taken with his Brooklyn patois and his street smarts. We were both getting over heartache and he invited me to Key West so we both could heal. Sometimes you need a lost weekend. The photograph that he took of me there is the closest to who I really am. He sees the truth.

The Real John Lennon
Barry Levinson

I was at a party in the fall of 1963, my first year at American University. I was, for a short period of time, living the college life. It didn't last very long, but one night in particular stands out. Some guy came into the smoke-filled crowded room with an album under his arm. He was half drunk. He yelled at the crowd and a silence fell over the room. "I have here the greatest album in history! The world of music is about to change!" Big laughter followed of course, and the college preppy walked over to the record player and carefully pulled the black vinyl out of its sleeve, gently placing it over the spindle. The needle slowly touched the spinning disc and, indeed, that was the moment a new sound filled the crowded room. The Beatles had arrived, and music did change.

John, Paul, George, and Ringo created a sound we hadn't heard before. For what seemed like minutes, but was actually eight years, the Fab Four dominated music, constantly changing. And then it ended. The Fab Four were no more. The Beatles moved on to separate careers. My friends were angry. I was angry.

Then, the real voice of John Lennon and his lyrics began to emerge. Sometimes it was lyrical and soft, sometimes Lennon was angry and harsh, sometimes the revolutionary man, sometimes a husband, an insecure man, a man of the world, sometimes warm, comforting, and tender, sometimes... and sometimes. John Lennon fully emerged, unpredictable and adventurous, a playful man, sometimes distracted, and we took that journey with him. Through his words and music, he made an indelible impression. He exposed himself with honesty; an imperfect man who wished for a better world. An optimist surrounded by the imperfect nature of mankind.

Brian's photos show in his encounters with John, a straightforward honest look at the man. No bells and whistles with Brian's photographs. His work has clarity and character. Brian's visual approach doesn't lead you, he offers unvarnished simplicity, a moment in time. That's his style; it's the simplicity of the moment that says so much, and there's a curiosity that lingers as we wonder what was the next moment like. It's always difficult to define talent. We can fumble with adjectives, but the final definition of his work is simple – just look at what he sees.

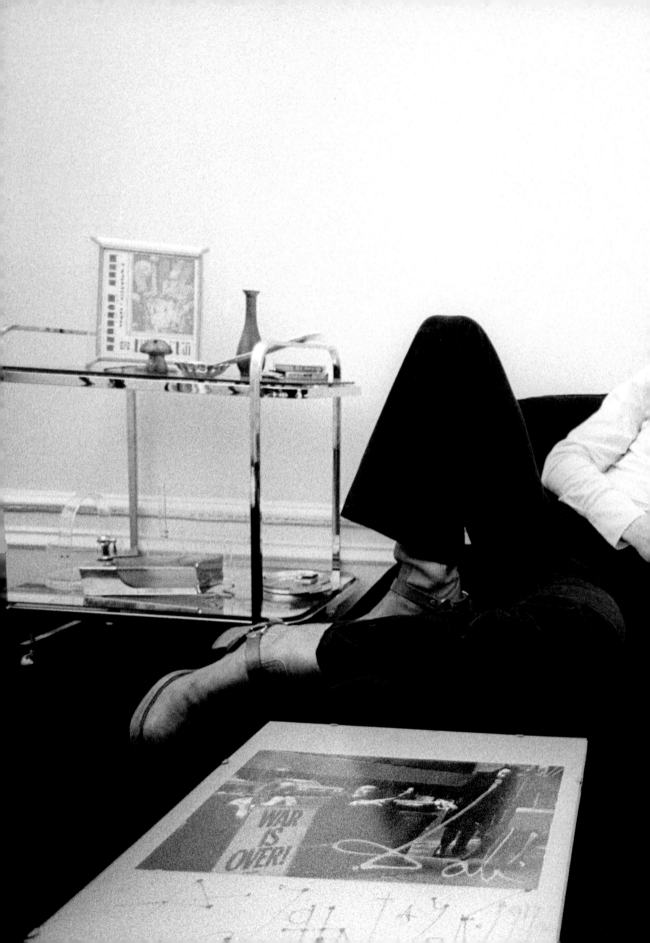

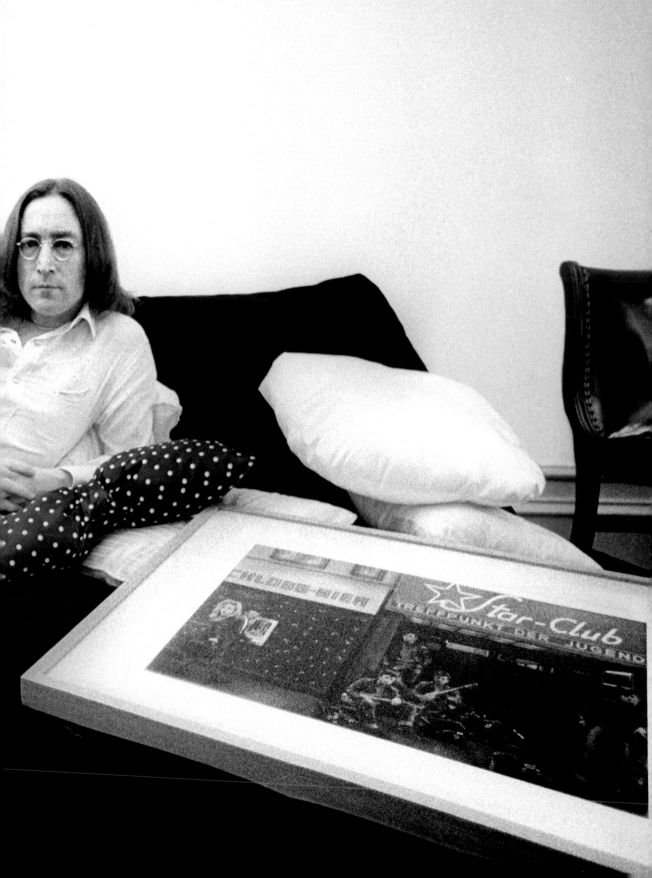

You May Say I'm a Dreamer
Brian Hamill

The first time I learned of The Beatles was in November, 1963 as a seventeen-year-old freshman photography student at the Rochester Institute of Technology. The Beatles were featured on the traditional-television *Huntley-Brinkley Report*, which outlined the phenomena dubbed "Beatlemania" raging across Britain and beyond. It whet my appetite to see more of them, but I was soon, several days after, distracted by the assassination of President John F. Kennedy, whom I loved. It took me several weeks to get over that tragedy. Then I started hearing Beatles songs on the radio. I first heard, "I Wanna Hold Your Hand" and then, "Please Please Me" and "Love Me Do".

I immediately dug The Beatles sound. Those songs and the responsibilities of ongoing life helped to cool-out my JFK assassination pain.

I had been a hard-core Rock and Roll fan since I was nine years old, after attending a live show with my older brother Tommy at the Brooklyn Paramount Theater. That show literally rocked my world.

Seeing was most definitely believing.

I'd already really dug Elvis and Chuck Berry and Little Richard and Fats Domino and Jerry Lee Lewis from my radio days. I also became an addicted Doo-Wop dude. The Moonglows, The Dells, The Cadillacs, The G-Clefs, Danny and The Juniors, Frankie Lymon and The Teenagers, The Teenchords, The Belmonts, The Cleftones, The Del-Vikings, The Drifters, The Five Satins, The Flamingos, and The Heartbeats all turned my head and infected my soul. They all got me off my young ass to boogie.

At that sensitive age, the music of my transformative teens neutralized any subconscious sense of poverty that I might have felt; a poverty which my Irish-immigrant parents struggled with in our family's tenement years. It was like a dense fog in our working-class Brooklyn neighborhood. We lived in a rough and tumble, often violent, hood where nobody had dough and few thought they could escape into a better life. It wasn't until I arrived at college in Rochester, NY that I began to realize how meager and shallow my financial roots were in comparison to many well-heeled fellow students.

The realization made me determined to work my ass off, much harder than they, at becoming a good photographer. My vision for a path out of poverty would be through my camera lens. My photographs would be a passport to a bigger world.

By then, my musical stash had grown to include Sam Cooke, Jackie Wilson, Smokey Robinson and The Miracles, The Ronettes, The Isley Brothers, and my man Marvin Gaye. My older brother Pete pulled my coat to a dude that he said had been making noise in the Village writing and singing songs that had poetic lyrical impact; Bob Dylan grabbed my attention big-time, especially with "Blowin' in The Wind", whose lyrics captured

the civil rights and progressive politics mood of needed, oncoming change. I started to be a fervent Dylan enthusiast. People said he was a folk singer but I thought of him as a poetic rock 'n' roller. In my hood, he became our poet.

And, of course, I was still down with Elvis.

So, embracing The Beatles with their own working-class roots, as dudes from the gritty streets of Liverpool, was a lay-up for me. Beatles covers of existing rock hit songs easily found fertile soil in my own historic musical tastes. And, more importantly, their original songs were a "groove". They spoke to me. They moved my emotions and my feet. I became an enthusiastic Beatles fan. I grew my hair long.

Much later, on August 30, 1972, when I was lucky enough to photograph John Lennon in his very last full-length concert at Madison Square Garden, my teenage instincts about him were confirmed. The charismatic dude on stage whom I so respected for his individuality, creative talent, and edgy urban voice, was performing with an abundance of human soul.

Yes, much earlier, on February 9, 1964, I was one of the 73 million fans who watched The Beatles perform live on *The Ed Sullivan Show*. The joint, all of America, was jumping as these four skinny dudes with long hair played their wonderful songs with legitimate self-confidence. They had seriously established themselves as a worldwide musical phenomenon. The Beatles were the first ashore and became the blueprint and spearhead of the British Invasion.

Watching them, I caught a vibe that John Lennon was the edgy/aggressive one. His face said to me, "Rub it on your chest!" That was '60s Brooklyn-speak for, "Whatever man; you don't like it, take a fucking hike!" There was something brooding and introspective about this special dude named John Lennon. He oozed charisma the way Brando did on screen, and Muhammad Ali did in the ring. I related to him immediately. I dreamed of someday photographing this bold artist. After listening to The Beatles sing on records over the years, I can still detect his stand-out, edgy voice. "A little bit of lunacy is good for everyone," said John, at

their first NYC press conference after landing in February, 1964; it made me realize that he would be the first Beatle to become outspoken and to swim against the tide.

So, I began to pay closer attention to John Lennon. To me, he seemed like the hippest Beatle and their natural leader. Of course, the John Lennon I came to meet later would have been the first to say describing him as a "leader" was nonsense. The edginess and non-conformity were probably rooted in his childhood loneliness, and in studying art at The Liverpool Art Institute where he still enjoyed the trippy Lewis Carroll books of his youth. These influences followed him into the public eye of his early success in Liverpool, Hamburg and London where, of course, his big dream was to be a world-famous rock 'n' roller, and where he surely did land.

Lennon made those dreams come true not just with luck and PR but with hard work, by never being satisfied, by always striving to be better and always to be different and surprising. Just listen to the early songs he wrote and sang, like "I'll Cry Instead" or "Help!" or "In My Life", where he was singing about his own unhidden truths or his internal conflicts. Or later Beatles songs, "A Day in The Life" and "Strawberry Fields Forever". Dig the edginess, the ever-evolving artist. In the 1975 classic "Fame", singing on his friend David Bowie's hit tune, the edge in John Lennon's voice is clearly evident. In my opinion, without that edginess in most Beatles recordings, those songs would have had far less dimension and more pop fluff. His vocal edge mirrored the essence of his character as well.

Part of Lennon's character was clearly forceful, and led to his occasional displays of impatience, which took caustic verbal aim at critics and the press. But he had more than a touch of sweet soul in his songs that often betrayed his fragility. In his Beatles days, his built-in behavior displays often bordered on a duality, a toss-up, of charismatic friendliness and all-out aggression, especially when dealing with the press. He could be a pissed-off, mean-spirited Beatle more often than his bandmates. It seemed, John Lennon had more complexity than Hamlet.

In October 1972, I got a dream assignment from *Parade* magazine to photograph John and Yoko, who had been living in NYC for about a year. I was both eager and nervous to actually be in their presence. I had read the many newspaper stories about John and Yoko's peace efforts with their organized fun festivities like the Bed-In for Peace. I did not get to photograph any of those events but they extended my respect for this celebrity couple. "Give Peace a Chance" is still an anthem for every organized anti-war effort.

On October 13, 1972, I took the subway with my photographic gear and an envelope of 30 (8x10) prints of my images from their concert at Madison Square Garden on the previous August 30.

On that subway ride to the West Village, I flashed back to when I came home from RIT in Rochester, NY for Christmas in 1963. I remembered seeing a sticker on a wall as I was headed for the subway at Grand Central Station after a very long NY Central train ride back home to NYC. The sticker said: "The Beatles Are Coming".

Cool. No date, no location. Just cool.

John and Yoko lived at 105 Bank Street in the West Village. Having been a working photojournalist for seven years, as well as a movie-still photographer for two of those seven years, I had a solid foundation to do a good job of work. I was very soon, minutes away, to meet and photograph a Beatle in person. John Lennon, my favorite Beatle.

Beyond cool.

I was expecting a PR person to answer the door followed by a small entourage of make-up and hair people, along with a personal assistant or two to greet me as I entered their pad. Those types of folks came with the territory on a movie-business shoot.

Instead, John Lennon answered the door.

Alone.

He had turned 32 years old just four days earlier.

He put his hand out and as we shook said, "Hello

Brian, I'm John. Please come in, would you like a cuppa?"

I declined his kind offer of tea, still surprised when the only other person present in their apartment was Yoko Ono.

No make-up, no hair, no PR people, no assistants.

No bullshit.

Just, John and Yoko. And me.

Cool.

We spent over an hour shooting inside and then on an adjoining rooftop reached by walking up a spiral staircase.

The three of us then spent a good deal more than another hour walking and stopping on the streets of the West Village. As the three of us walked along, John made a point of greeting lots of people with total respect and often with his charming, natural, sincere humor. I never detected either of them making themselves seem more important by making any others they encountered feel less important.

I photographed them enjoying their stroll, looking in mom-and-pop shop windows, and eventually going inside a shop on Bleecker Street as Yoko spotted something that provoked her interest. This particular location was the only time on this entire shoot where I noticed John's slight annoyance with another person.

Yoko entered the shop first; John gestured for me to enter next. As I entered, there was a guy lying in a hammock in the very small space. He started to rise up from the hammock as he saw me with a couple of Nikon cameras around my neck, but he suddenly lay back in the hammock as he locked his eyes on John, who followed me a half-second later. There was a long pause before Yoko addressed this guy, asking him if he worked there. He glibly answered, "I own it."

He still lay in place in the hammock. Yoko started looking at the sweaters when another guy came from behind a wall in the back of the shop. He,

the employee, was very pleasant to Yoko. They chatted up sweaters.

John remained, arms folded, standing by the door just inside the entrance. He didn't look happy. I picked up John's vibe about the owner guy still in the hammock who remained wordlessly unfazed.

Annoyance.

My street-guy antenna was up and I pinned John's sour vibe correctly. Hammock-dude was trying too hard to appear unimpressed with the presence of John and Yoko. The physicality of the dynamic prevented me from capturing the photographic image of the three of them in the same frame. But I clearly understood where it was at from John's body language.

The owner dude thought he was cooler to play us off by remaining horizontal and aloof, by not engaging any of us in a friendly way. It was the flip side of an annoying, gushing fan that a celebrity cannot cut loose politely. Hammock-dude continued lying in the hammock like a lump on a log as the three of us exited his shop. John made a brief mention to me of his displeasure with Hammock-dude. He didn't "run it in the hole" (Brooklyn-speak) talking about it endlessly, and he let the negativity go quickly. Not sure if Yoko even picked up on it.

I could vibe that John did not let the incident bother him much more. I did not bring it up, and had zero frustration with myself for not getting a decent three-shot of Hammock-dude, John and Yoko.

John carried the shopping bag with Yoko's new sweater for the remainder of our time together.

We continued on to John and Yoko's "favorite spot" in their immediate West Village hood. We went further west, over to the end of the Bank Street pier as the October afternoon light was getting pretty. John said, "This river is magical!" The photograph of them in that "favorite spot" was a special image-capture for my professional self-satisfaction.

A few months before my Bank Street session with

John and Yoko, I had finally read the novel *On the Road* by Jack Kerouac, and it was a top-shelf odd-ball read. It had moved me. It reminded me of my street-guy friendships with two dudes I met in the first grade of our Catholic grammar school at age five in Brooklyn, and who are still my two best friends.

The fictional Dean Moriarty was based on Kerouac's real-life friendship with Neal Cassady. And even though John and Yoko were husband and wife, my three hours-plus time with them on that October 13, 1972 made me think that they weren't just married lovers, but more than that, they were wonderful, very close sidekicks, as were those wacky Beat generation pals in *On the Road*. They hung out together, enjoying each other's company on an hourly basis.

John and Yoko were exceedingly nice to me, and whenever I hear either of them get bad-mouthed by anyone it truly upsets me, and I don't hesitate to verbally defend both of them. Unfortunately, Yoko has had to be the recipient of most of the undeserved mudslinging over the years. Why? Was it because she helped liberate John from the chains of his unhappy life with The Beatles? Who among us hasn't quit a job they felt was toxic and unfulfilling? I wasn't alone in thinking that Yoko became a convenient scapegoat for all the negativity that went down about The Beatles' breakup. In point of fact, she had been, and remains to be, an honorable wife and sidekick. What other widowed wife carries on a dude's legacy as reverentially as Yoko has done for John Lennon?

Moreover, Yoko Ono's work, which was separate from her life with John Lennon, has been misunderstood, repeatedly dismissed and judged poorly. She had been a working artist long before John Lennon got to meet her. Her conceptual work is mostly witty, often smile-provoking art. In 2015, MoMA finally gave Yoko much-deserved props by mounting a retrospective of her early, Zen-inspired works. Those works gave many, myself included, very pleasing, artistically worthwhile, and fun emotional results.

On February 25, 1975, I had the pleasure to photograph John Lennon again. As he did when I

first met him three years earlier, he answered the door himself. He and Yoko had been living since 1973 at The Dakota on West 72nd Street and Central Park West. They had two apartments, and Yoko had a separate office in the same building on a lower floor. I took the elevator to the seventh floor and John greeted me very warmly:

"How have you been Brian?"

"Good man, and you?" I said.

"I had a strange year, but all is cool now. Yoko has work to do downstairs in her office so she won't be joining us. I am all yours."

I never got nosy by asking about his strange year. I let that lay, and I will let it lie here. As my old man once said to me, "Those who gossip with you, will gossip of you." The apartment was sparsely furnished as if they, as a couple, hadn't quite finished their final touches with it yet. Again, just as he was to me in 1972, John was totally friendly. I noticed he ran his fingers through his longer (than 1972) hair. I flashed back again. The Beatles. Long hair. They made it much hipper than George Washington.

I asked if he was ready and he said, "Yes, shoot away." I was much more relaxed starting this photo session than I had been in 1972. We roamed through a couple of rooms and I did exactly what he suggested. All of the rooms were big. We ended up in a room that had a large bed, presumably it was their bedroom. I asked him if I could photograph him on the bed (as I had done in 1972) and he said, "Sure, let's put some stuff on it with me." He retrieved a couple of fairly large, framed pieces. One of them looked like a poster with a photograph of Salvador Dalí inside the graphic. He told me the other one was a photograph taken by Jürgen Vollmer, who had done clusters of very nice photographs of The Beatles early in their career in Hamburg. He spoke respectfully of Jürgen and his work. I got the feeling John considered him a friend. He told me Jürgen "wanted to do movie stills like you do, too," but had experienced a tough time getting into that field. And I told John that I was very persistent when I tried getting into the same racket, and finally my perseverance had succeeded.

We entered another big room that had a jukebox in it and an art piece of a pair of neon lips above the juke. On the left side of the juke was another Jürgen Vollmer photograph on the wall, and it was also framed. I asked John to stand in front of the jukebox and he didn't hesitate. Within seconds he turned over his right shoulder, and asked if I had any requests. I said, "Do you have any Marvin Gaye?" He said, "Yes indeed, I love Marvin Gaye." And John Lennon put on "What's Going On", and Marvin's sweet voice filled the room. We both were silent as Marvin Gaye's singing drifted into our heads. Then John started singing along, and knew every word! It was a cool moment. A very cool moment. Life has a series of cool moments, and this one was one of the coolest for me. And I thought that somehow the idea of jukebox-delivered music made it more social and nostalgic, more like my early teenage doo-wop days, hanging out in candy stores back on the block with my homeboys.

Then, of course, I almost fucked up that cool moment with my next unthinking, spontaneous, utterance to John: "This Marvin Gaye album is the most inventive album of the '70s so far!"

Oh shit! What the fuck did I just say to John Lennon? What a fucking faux pas!! I better dig myself before I be by myself!

We all have said stuff in life – a sentence, a statement, a paragraph, an inappropriate cluster of words that we wish we could have shoved back into our mouths before they floated out into the actual live sound of reality, in a self-censorship kind of way. After all, I quickly realized, John Lennon had released at least four or five very good albums in the early '70s, including his fantastic 1970 album, *Lennon/Plastic Ono Band*.

But then, as if a gift sent to me from above, to help neutralize my horror of immense embarrassment, John quickly said: "I agree, it's a fantastic fucking album!"

Now I realized, again, I was in the presence of a very special man. Not many celebrity types would have responded so graciously. When the great Marvin song ended, John said, "I have The Ronettes, Smokey Robinson, Wilson Pickett, The Marvelettes, Chuck Berry? Any other requests?"

I was still trying to recover to a calmer head from my bold – but honest – Marvin Gaye statement, so I said: "Play something you dig." And John said, "I dig them all or they wouldn't be in here," and then tapped the juke and "Shout" by The Isley Brothers rocked the room. As John looked, now smiling, over his left shoulder to see my reaction, somehow that get-up-and-dance classic calmed me even more after my verbal fuckup.

"Calmness is strength!"

This piece of sterling wisdom is from the late great boxing manager Cus D'Amato (who managed three world champions: Floyd Patterson, José Torres and Mike Tyson), who had taught me a series of essential boxing moves in the early '60s, but also, more importantly, many life lessons about how to behave. I try to apply that wisdom and Cus's advice in my everyday life. I was dancing alone, in place, which helped to calm myself further while simultaneously shooting with my (dance partner) Nikon. John got into it too. Seemed like he could sing along with anything, and knew all the lyrics too.

These flashback moments still break out of my brain now and then, when I least expect it. Yeah, life is a series of moments.

Moving into the kitchen, I noticed an Asian woman ironing clothes in an adjacent room. John said he had to write some lyric ideas down. He sat at a small wooden table and jotted down his "ideas" on a piece of paper that already had existing words written on it. I made a few photographs of him doing that in near silence; the only sound was the clicking of my Nikon's shutter. He was lost in thought so I cooled-out shooting for several minutes so as not to disturb his process. Suddenly, John said, "I am fucking ["fooking", Liverpool-speak] hungry! Are you hungry?" I said, "Sure I could eat."

"Would you like a toastie?"

"A toastie?"

"Oh, you guys call it a grilled-cheese thing."

I said, "Oh nice, sure."

It being the politically incorrect 1970s, I was thinking John would ask the Asian woman, still ironing, to hook up the eats. He suggested I put my cameras down and relax. Which is exactly what I did as I sat down at the small kitchen table. Then he walked to the fridge and took out Fairway sliced, white cheese wrapped in wax paper, and then took out a loaf of white bread from a bread box. And he picked up a butter dish which had been on the counter. He then proceeded to heft out a large black frying pan from one of the white kitchen cupboards. I was still half expecting him to ask the Asian worker to handle the deal, but to my surprise he made two delicious grilled-cheese sandwiches with speed and skill.

John Lennon, my true working-class hero, did the honors himself.

Damn real, bro!

He hooked up the plates and quickly added some chips. And we ate. He scarfed his toastie at lightning speed. This cat was hungry! It would have been a complete drag of me to grab my cameras during this private eating moment to shoot. Sometimes it's better to cool your own road and behave. Which I felt was the only respectful thing to do. I let that professional thought lay. I wondered the next day about his asking me to put my cameras aside and relax. I am glad he did. Another special moment with John that will stay with me forever.

I decided to break the silence with small talk:

"Whatever happened to your paisley painted Rolls Royce?"

"I gave it to that asshole Allen Klein. Then I got a completely black Rolls with tinted windows. When we were driving through Spain, old ladies would bless themselves thinking it was part of a funeral procession."

We both laughed.

John Lennon was a fun dude.

The Asian woman entered the kitchen with a pair of John's jeans to get his approval. They were

perfectly ironed with a crease straight down the middle of each leg, like a crease one would expect to see on dress pants. John had another chuckle, and politely explained to the woman that jeans need not be ironed. We all smiled.

I asked, "How are the graphics on the roof?"

"Great fucking graphics," he replied.

So up to the Dakota roof we went. John had put on a velvet jacket that had a diamond "Elvis" pin on the left lapel. It was a great look for my photographs. An icon wearing an icon's pin. Can you dig it?

On the roof it was very windy, but rather mild in temperature for February 25. He put on an oversize, cool-looking French beret that had been in the jacket pocket. I had a cap in my coat pocket that I had taken off and pocketed earlier, just before I entered his apartment. I took out my snap-open cap, very similar to one I had seen John Lennon wear exactly that same way in many photographs. It was exactly how I'd worn my own cap for years.

I saw John giving my cap the once-over look as I settled it on my head. "Sorry John. I copped your style," while pointing to my cap. He gave me a thin smile and a slight chuckle, but did not comment.

The wind off the Hudson River grew more intense, but the graphics were too good to not stay and shoot. John's hair was blowing like crazy. I told him about his hair blowing and he said, "I don't care, do your thing." I was pleased with the results of the photographs despite several that looked way crazy. But the wind gave some of my Dakota roof images a cool movement.

When the wind calmed down a bit, I asked John if Bob Dylan had ever been an influence on his music. "There are many Dylan songs that I am in awe of," he said. "His lyrics are terrific on so many of his songs." But pointing to his Elvis pin, he said: "But Elvis was really my biggest influence. He made me dream of becoming a Rock 'n' Roller."

I let it go after that exchange as there was nothing more for me to add to that convo.

Fairly soon after, I felt it was time to finish up.

There was something even more peaceful and certain to John Lennon's core during this special time with him. I felt like he enjoyed his escape from the Beatles thing even more. And now that he did, he would never look back.

In 1975, there was just something about his persona that rang true. He was authentic. He was sincere. He was centered. He was a standup guy.

I am not now, nor have I ever been, a Lennonite. I am an avid reader but not a research freak. I have never read a single text-only book on The Beatles or on John Lennon. I do not read blogs of any kind, although I am sure I will get inquiries from a chunk of people who do. I do, however, own a copy of Bob Gruen's book of photographs, *John Lennon: The New York Years* (Abrams, 2005). Bob Gruen is a very nice cat who signed his lovely book for me, and it is obvious that he works very hard. He has an extensive file of Rock 'n' Roll work that I enjoy and respect.

So there is not much more I can add to my own John Lennon memories than what you can read here, or get from looking at my photographs, so please don't expect any solid answers. I photographed him on three different occasions and had personal interactions with him on two of those days. In that sense we were partners in a photographic process. He was an iconic subject and a great and easy dude to photograph. I will be forever honored that he invited me briefly into his life with enthusiasm and good humor.

Sometimes it's hard to keep your faith in man. Sometimes the human race is a big disappointment. I will not give the bum who murdered John Lennon another sentence than I did when I wrote the below piece many years ago. Just hearing that swine's name makes me want to puke. And his name will not be mentioned between the covers of this book.

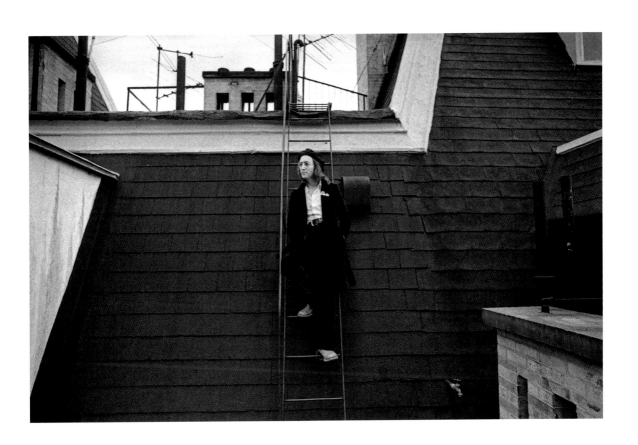

Gone But Never Forgotten

There are three crucially important events that happened in my life where I can remember clearly who I was with and what I was doing when they happened. The whole world was a witness to all three of them. They were all defining moments in our global history. Unfortunately, they all involved the death of good people.

The assassination of JFK on 11/22/1963.
The assassination of John Lennon on 12/8/1980.
The assassination of 2,752 people at the World Trade Center buildings on 9/11/2001.

If you were alive with a working memory during all three you will probably feel as I do, and remember most of the sad details. I can also throw in, with the same importance, and feeling of "coming together" in our grief afterward, the assassination of Martin Luther King, and Bobby Kennedy too. It is very sad to have to remember – and celebrate – great people in this way, but because of this unique time in our troubled history, a big part of me does exactly that – that's just the way it goes.

I am not going to give you any new perspective or cultural insight into John Lennon, although I will say that for my generation, and for many other generations, he was a major musical force and a phenomenal creative icon of the 20th century who influenced the world. No doubt about that.

But I will always remember John Lennon as a quick-witted, vulnerable, stand-up, soft-spoken, but unafraid guy. In my short time hanging with him, he spoke only the truth. I only spent time talking with him twice. I photographed him three times. They were all as unforgettable in my mind and in my heart as the awful day when he got murdered by a two-bit swine. On the night of 12/8/80, I was sitting on a rocking chair in my living room at my country house in Rhinecliff, NY, holding my three week old infant daughter, Cara, in my arms, just the two of us were there, listening to music together on the radio, me playing corny dad with the goofy faces, and smiles, and the baby talk, when suddenly the music was interrupted by a startling news bulletin stating that John Lennon had been murdered. Murdered! Shot to death outside The Dakota! Projectile tears instantly shot out of my eyes onto my beautiful baby daughter. I had never cried like that before. They were such immediate, forceful, heavy, flying, thick tears. I will never forget the twisted combination of emotions zipping through my brain, hitting me like a one-two punch on the chin. I was celebrating the wonderful joy of fatherhood one moment, and suddenly that feeling was completely shattered in a split second by a tragic, painful moment in the form of a horrible news bulletin. John Lennon is dead!? Noooooooooooo!

John Lennon never got to fully mature as a man. The dude was only forty years old! He never really got to bring his full genius to all of us. Although he certainly brought us some real genius often, and that is part of his tremendous legacy. He never got to share more of that fun, and laughter, and wackiness with Yoko that we all were lucky enough to glimpse in a small way, and you know a lot more of that was certainly coming on their horizon. He never got to spend a lot of quality time with his nice, sensitive sons. Yet he gave us all so much. Those John Lennon tears of mine will never fully dry.

He will be missed forever.

IMAGINE?

John Lennon's life was short but his fantastic music remains everlasting. He carried peace in his mind, freedom in his heart, and music in his soul.

When I was leaving John and Yoko's Dakota apartment on the last day I saw him in person, on February 25, 1975, John walked me to his door and put his hand on my back and said, "Hey, Brian," as he pointed to my cap. "Don't worry about copping my style, I copped it from Dylan!" We both laughed again and then I was gone.

And then on December 8, 1980 so was John Lennon.

You may say that I'm a dreamer, but I believe John Lennon will live on forever in his music.

And I'm not the only one.

 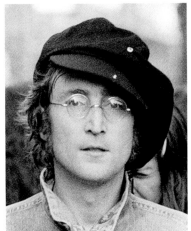 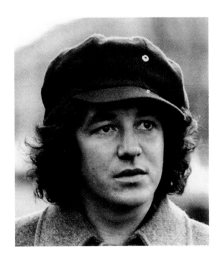

"Don't worry about copping my style, I copped it from Dylan!"

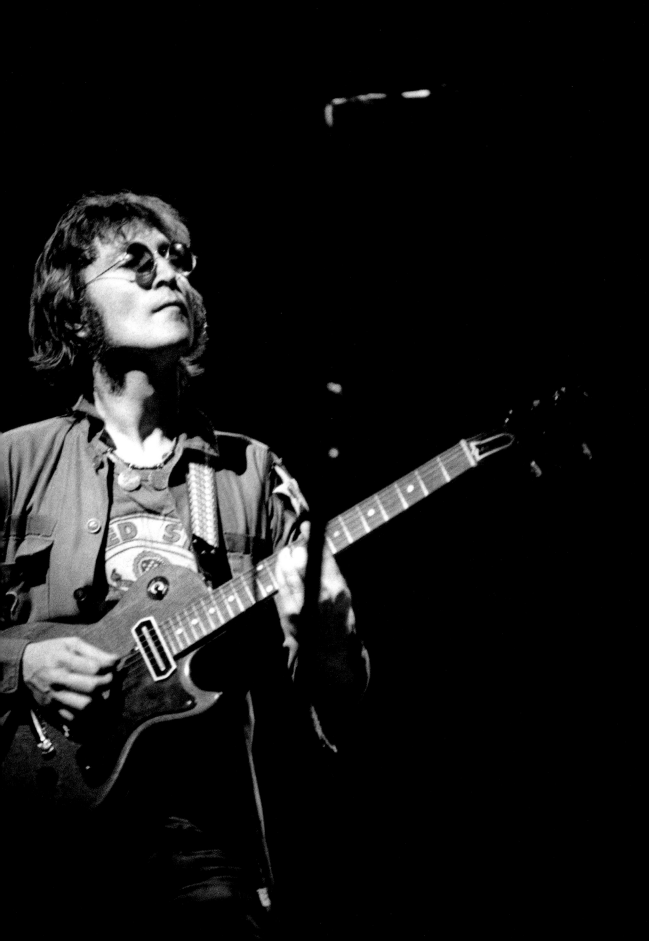

Madison Square Garden: August 1972

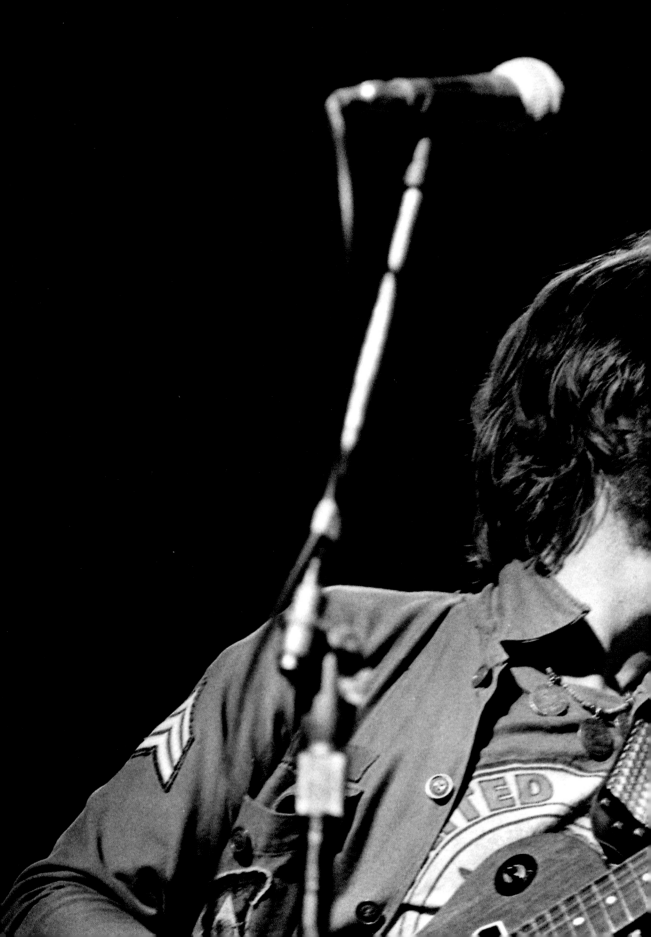

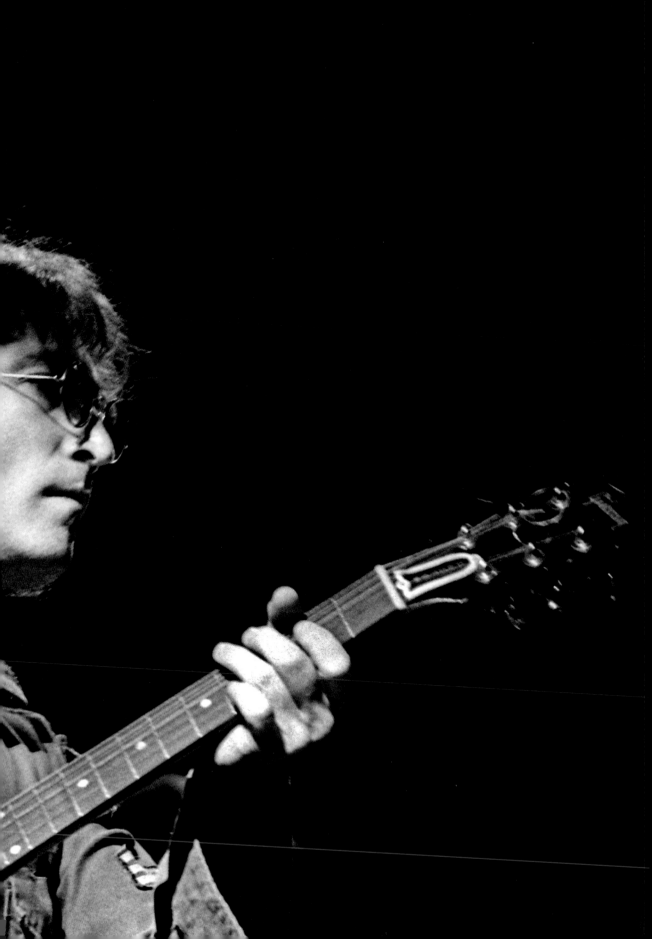

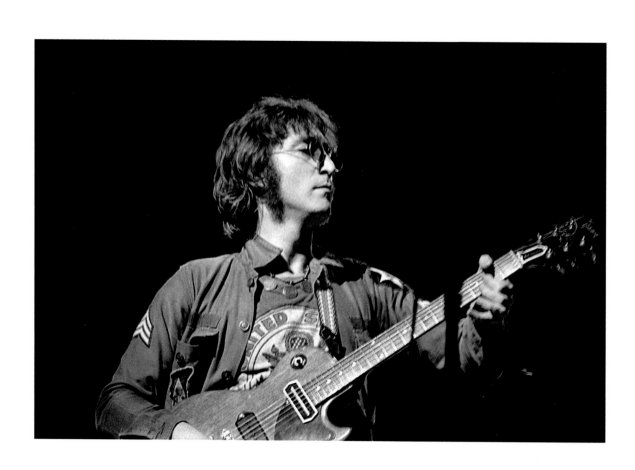

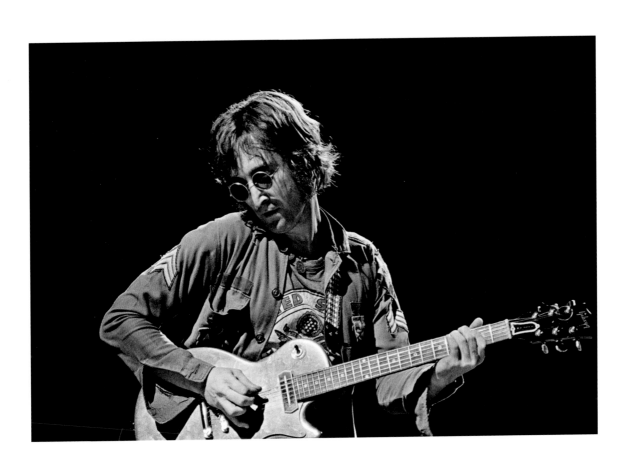

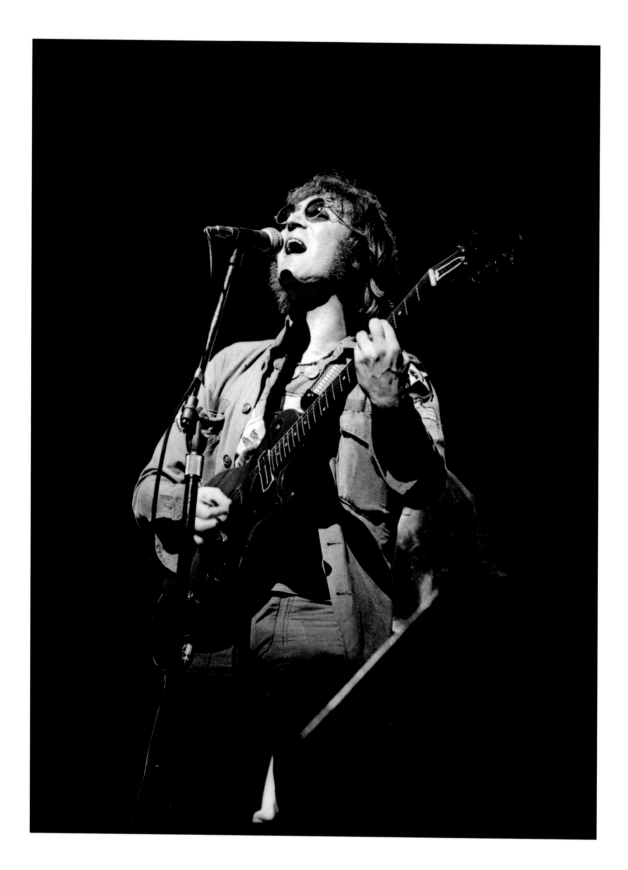

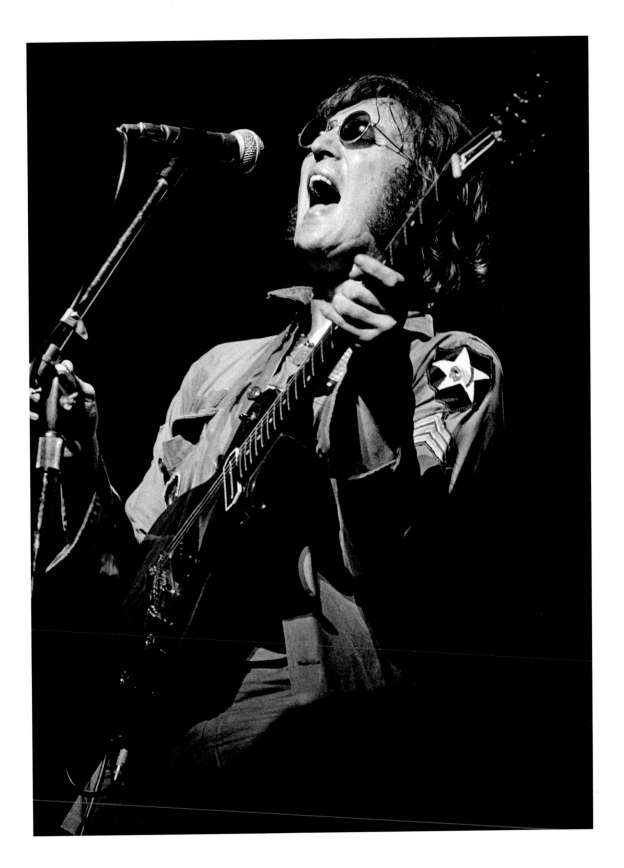

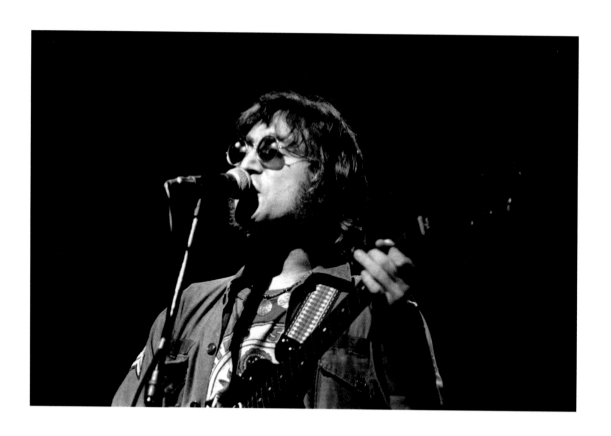

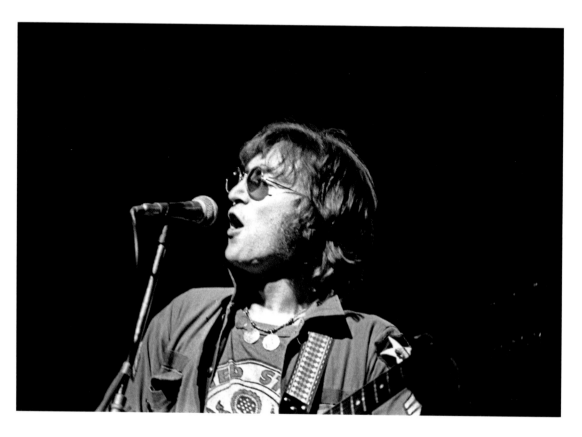

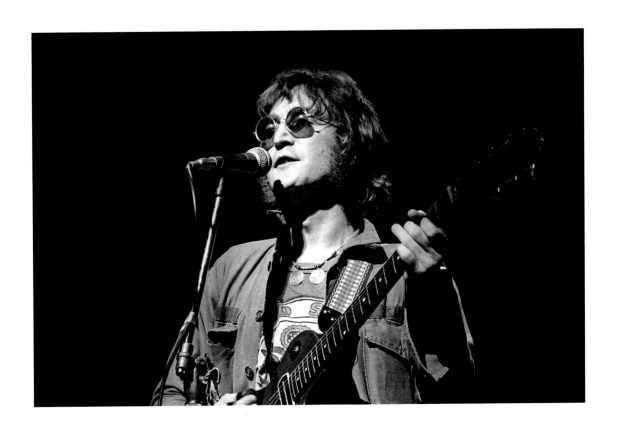

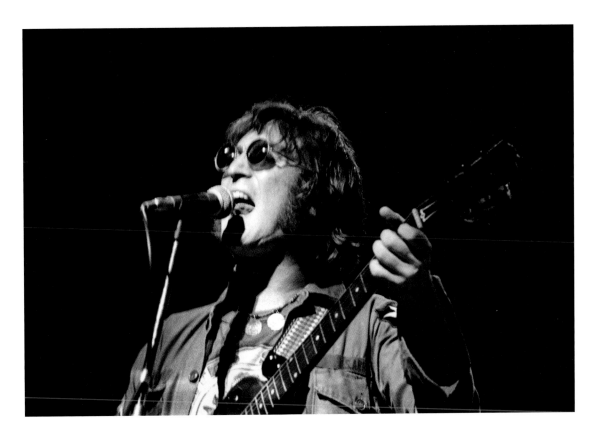

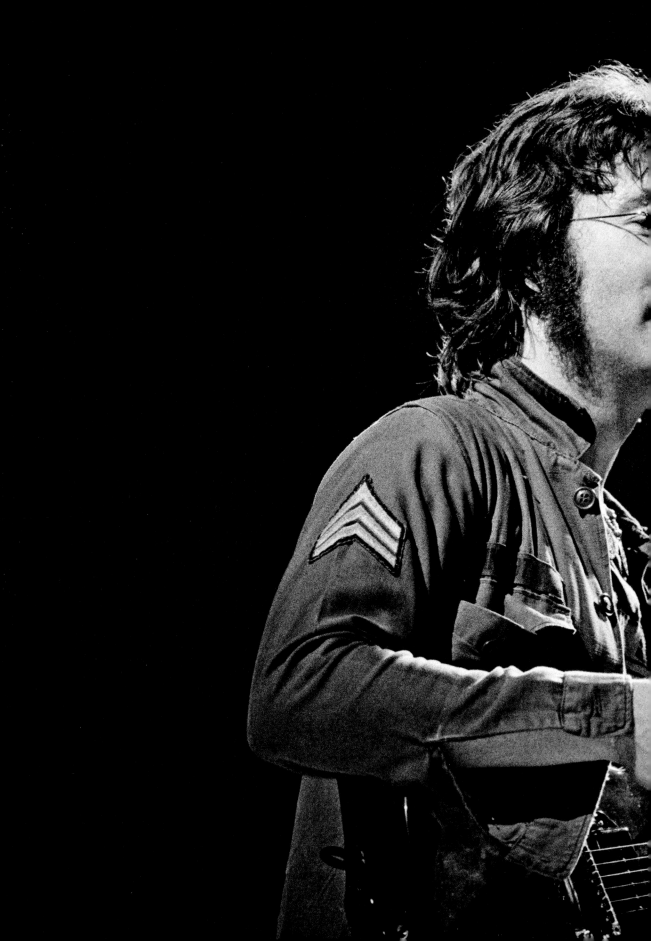

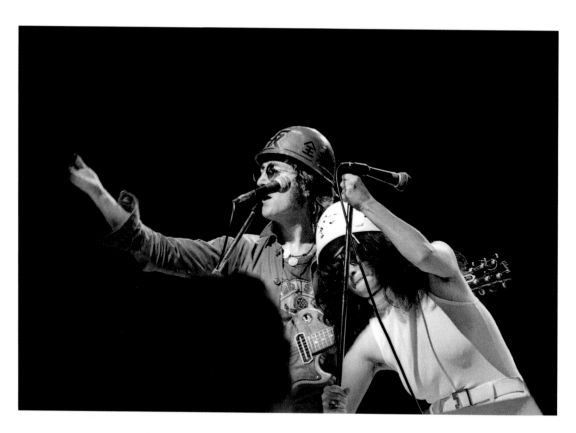

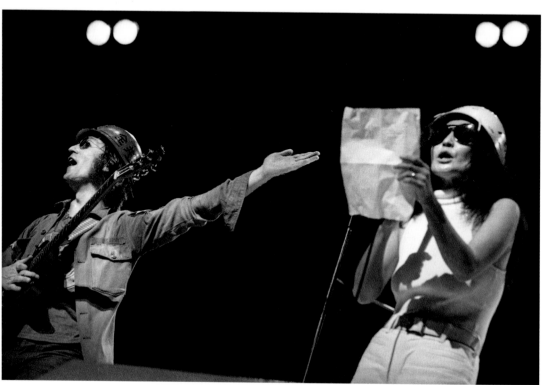

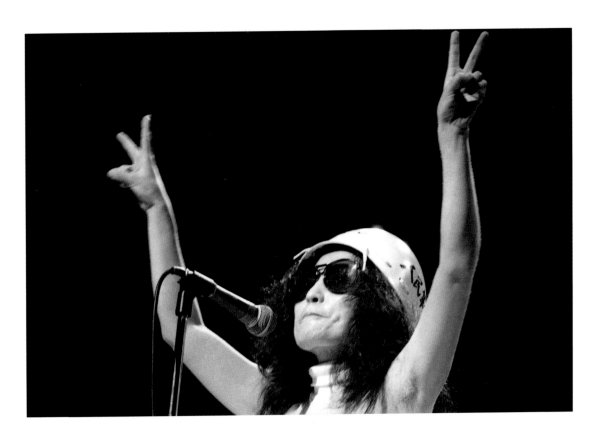

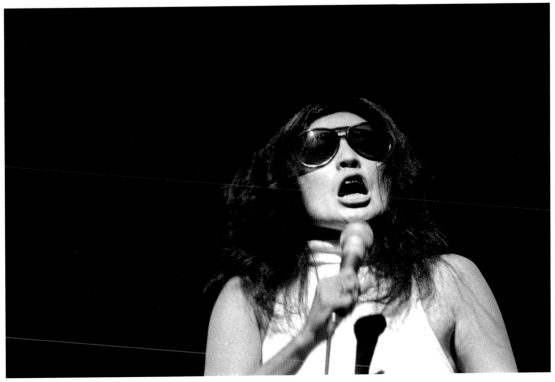

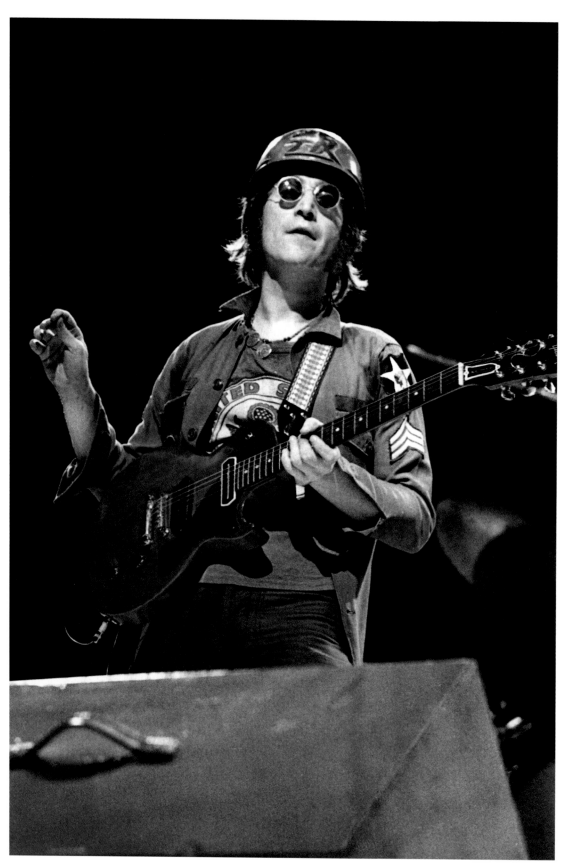

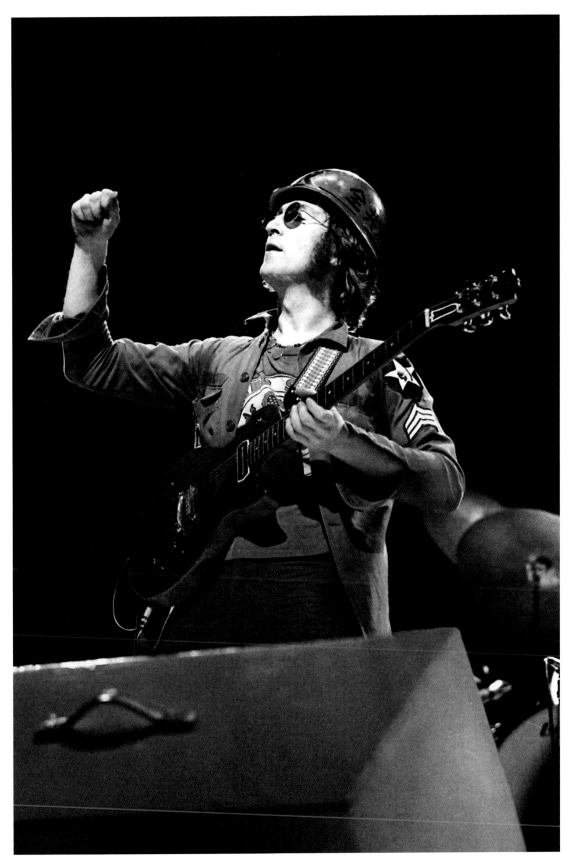

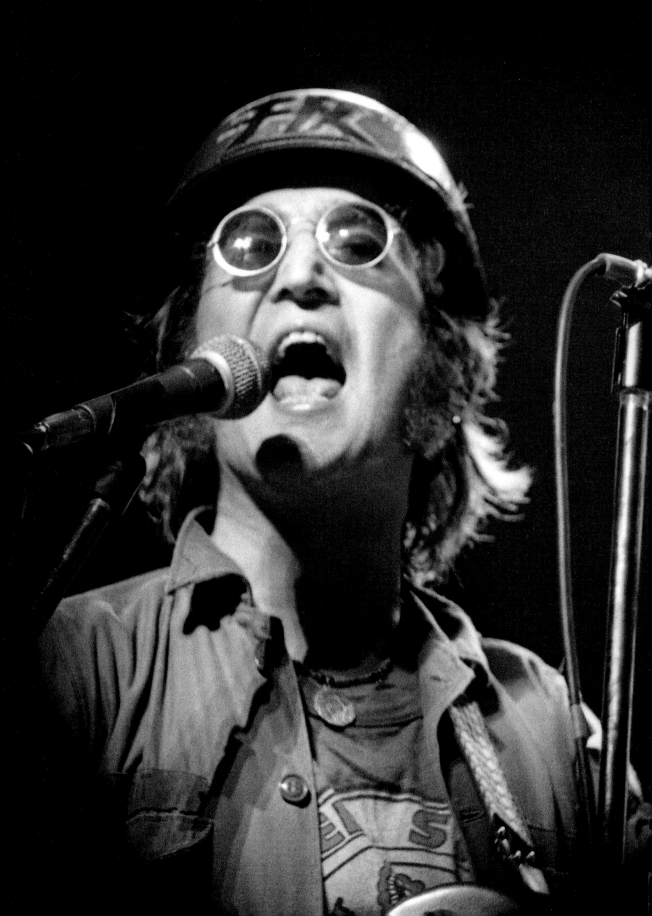

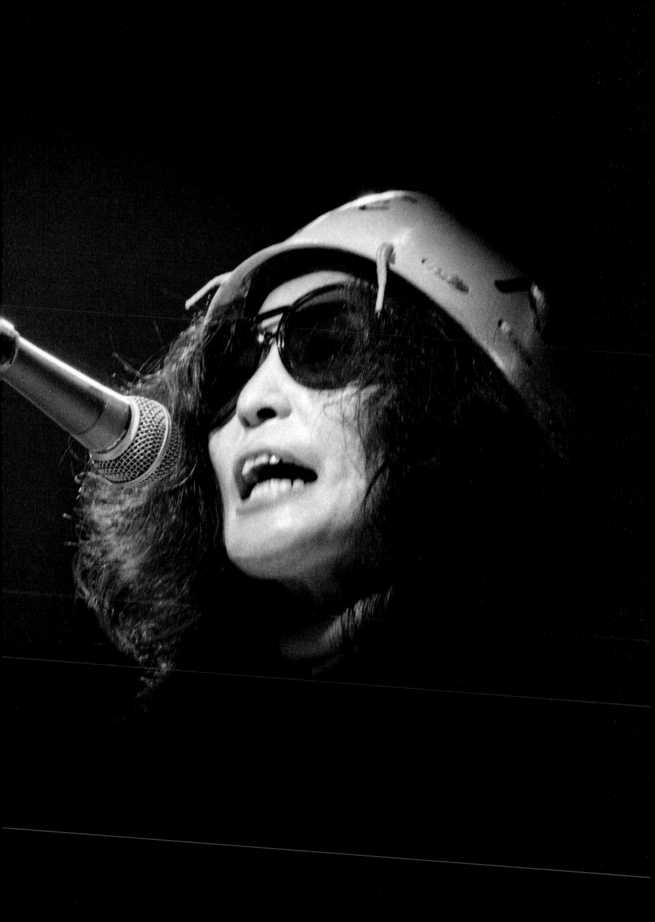

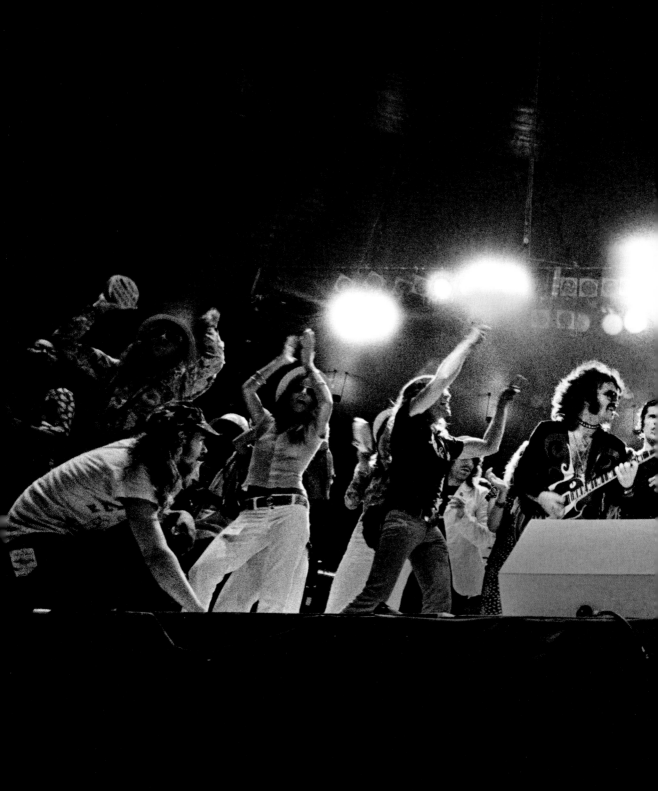

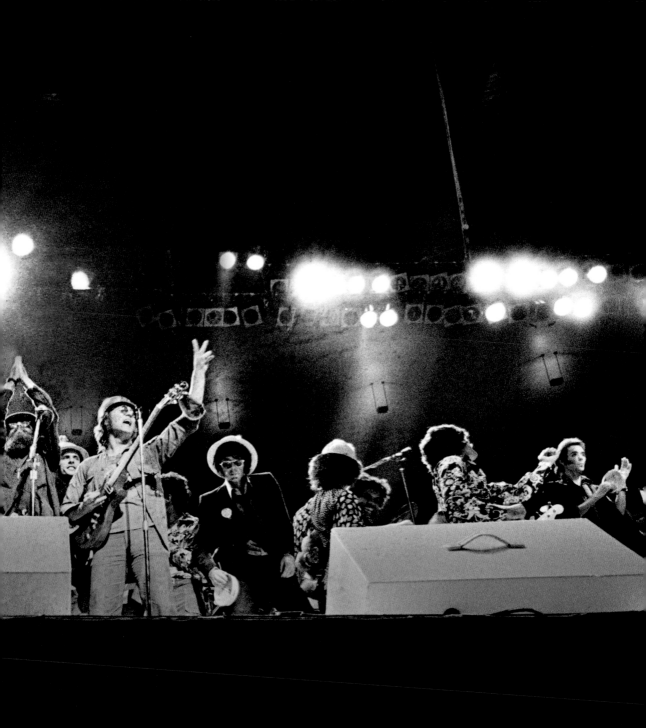

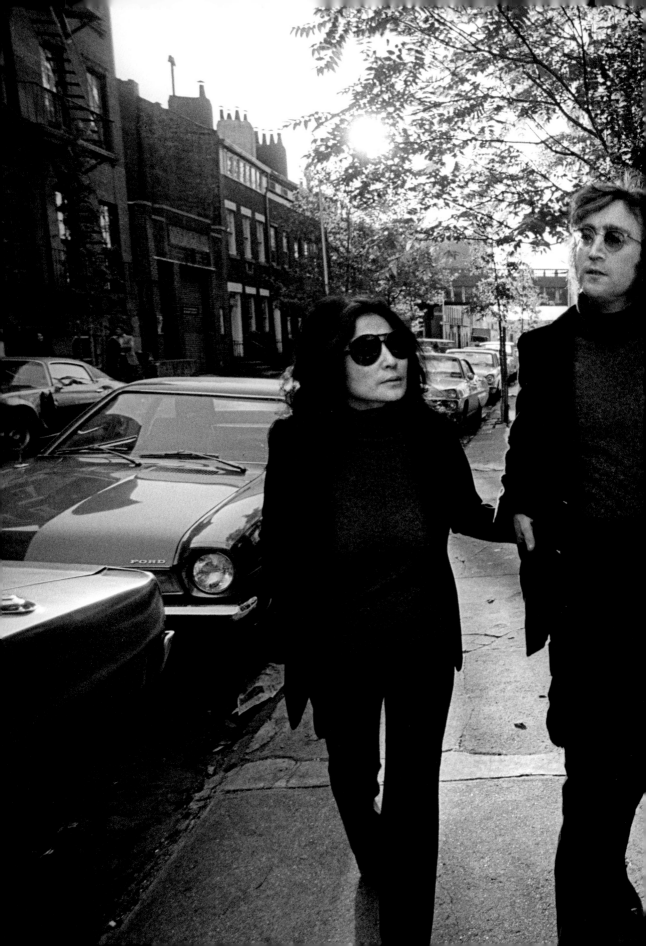

Bank Street and Greenwich Village:
October 1972

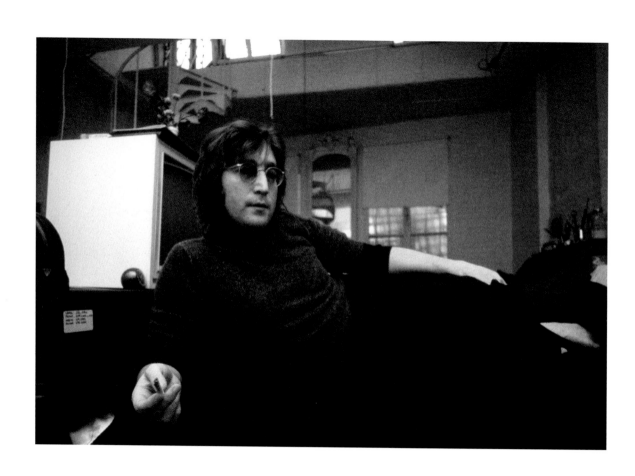

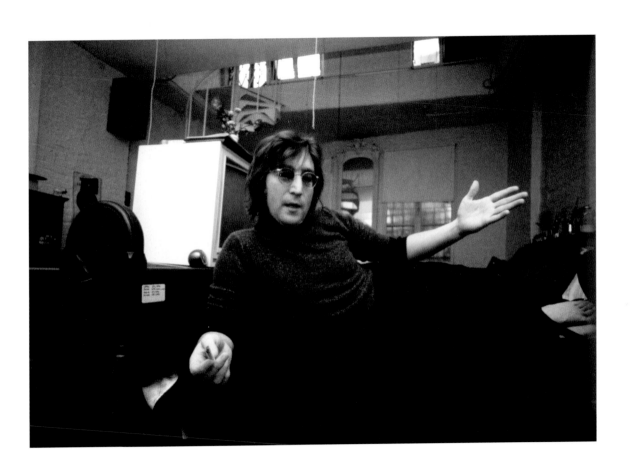

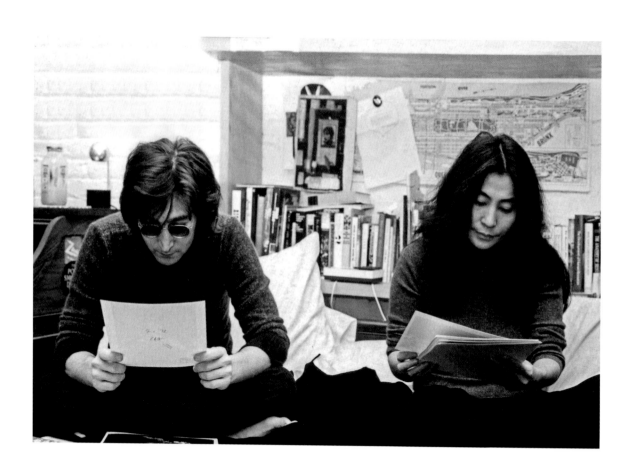

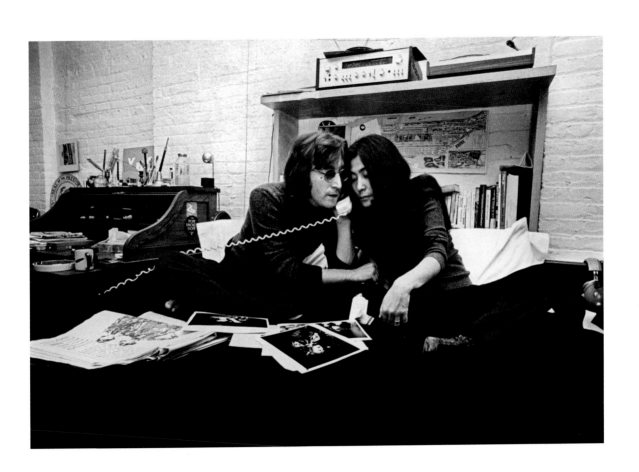

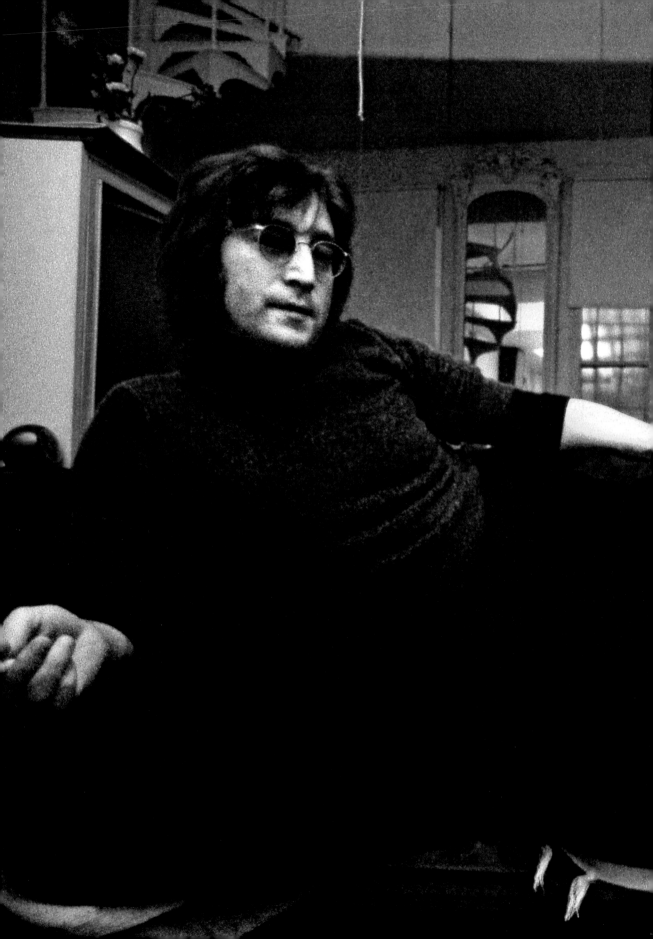

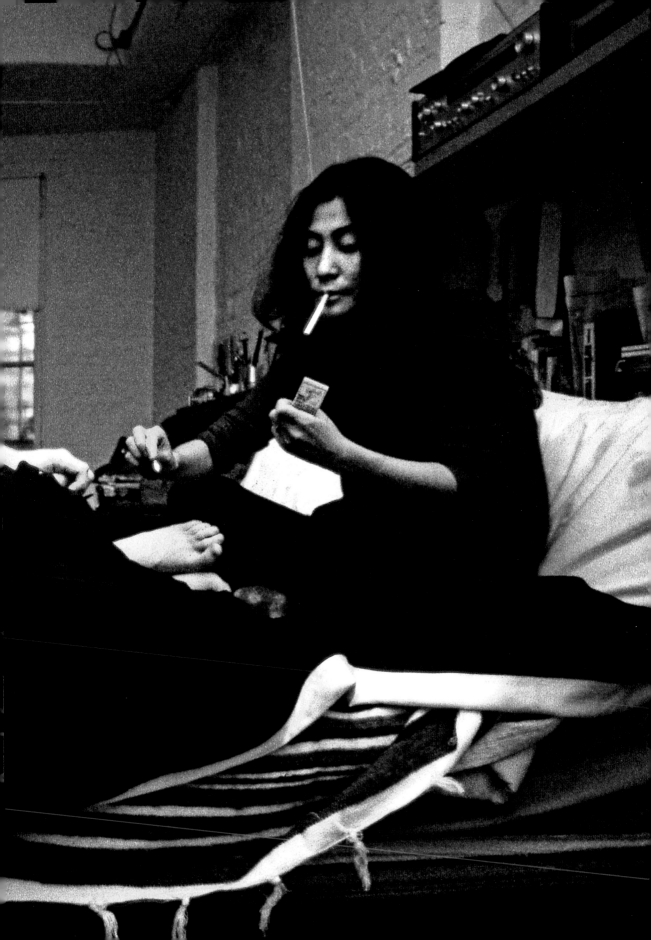

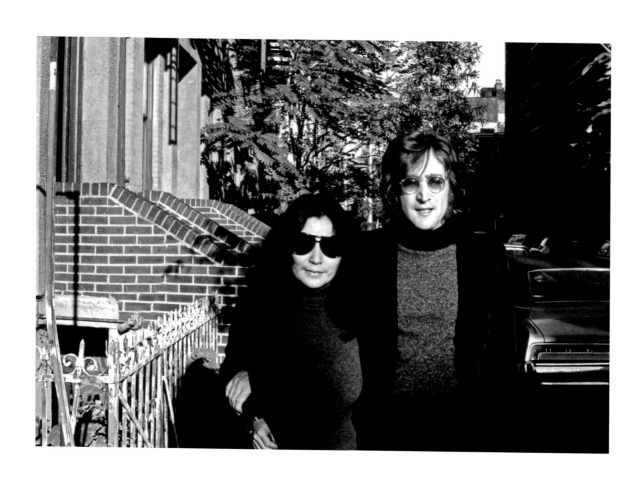

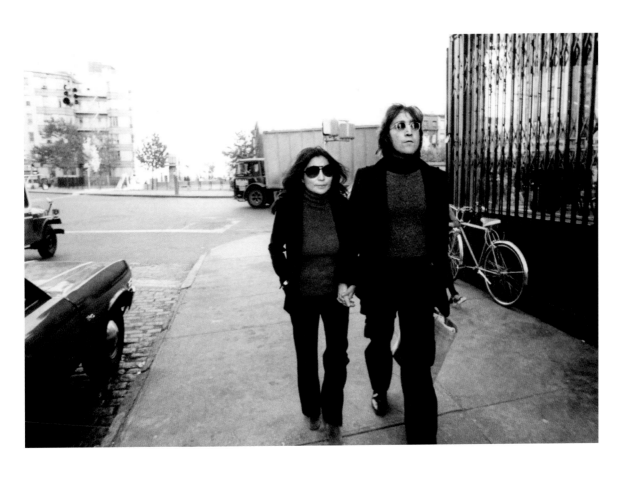

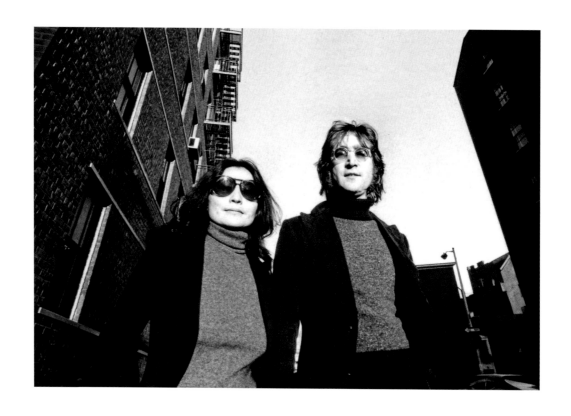

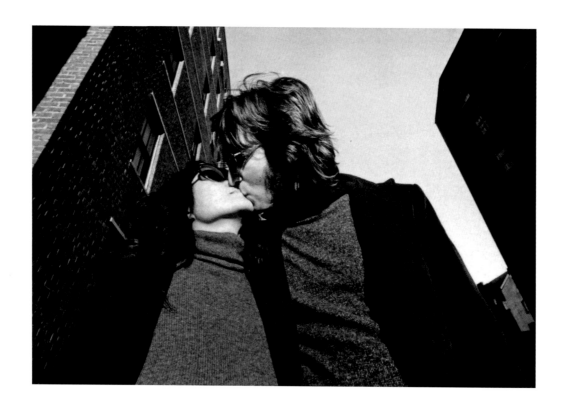

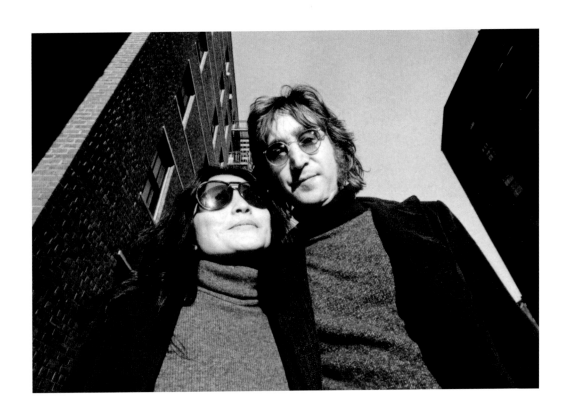

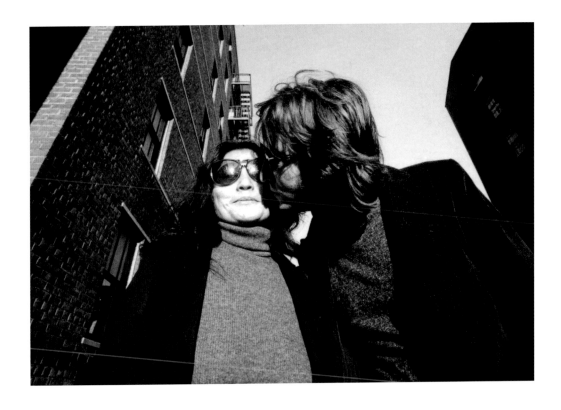

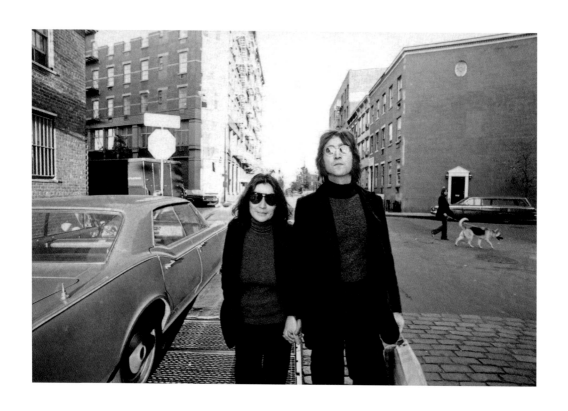

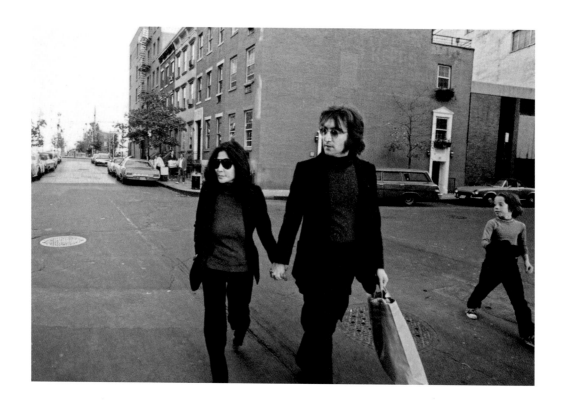

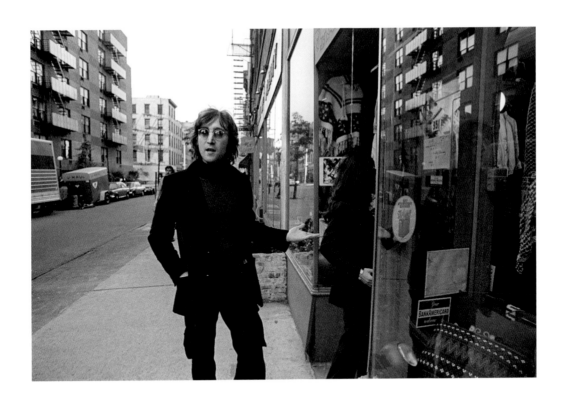

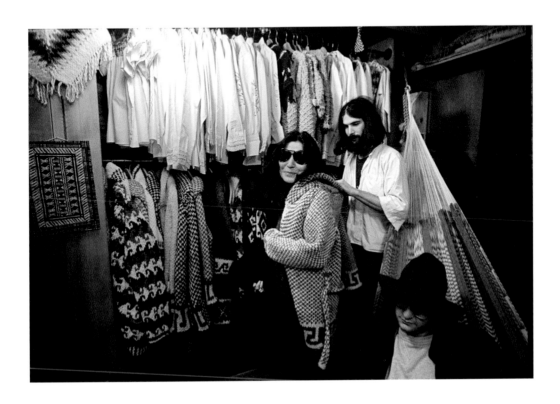

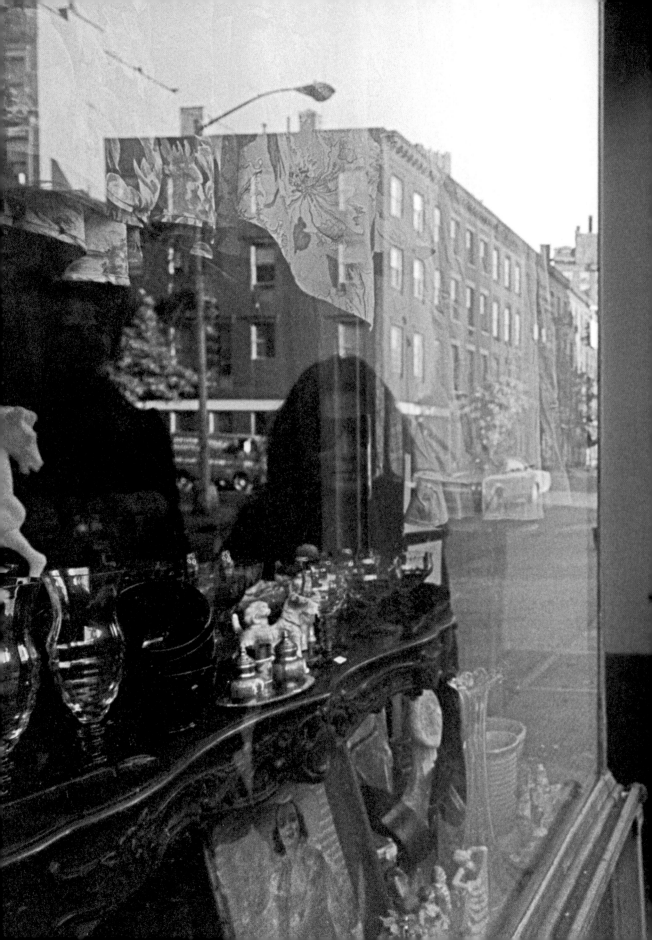

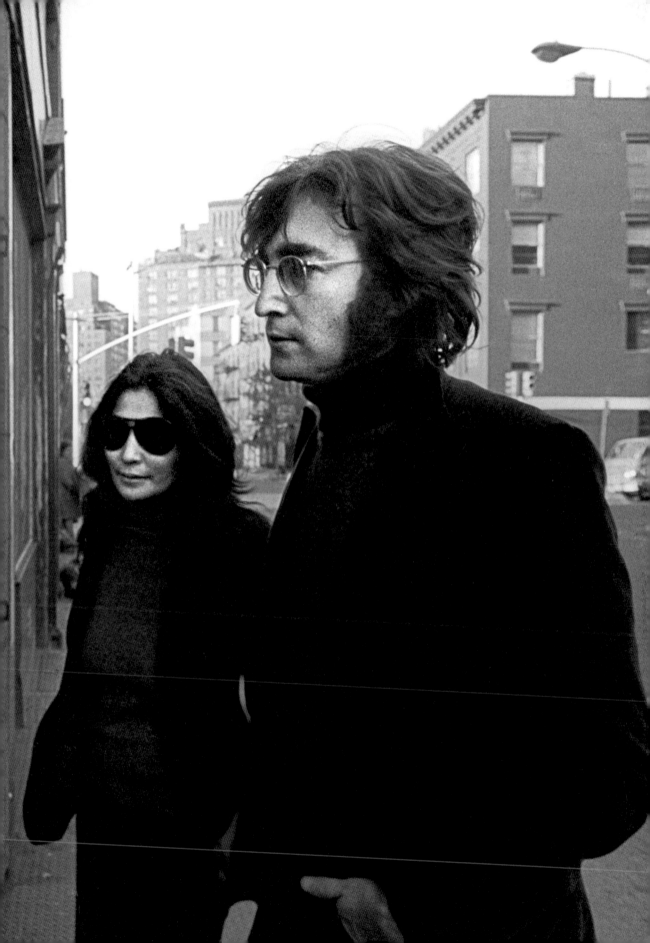

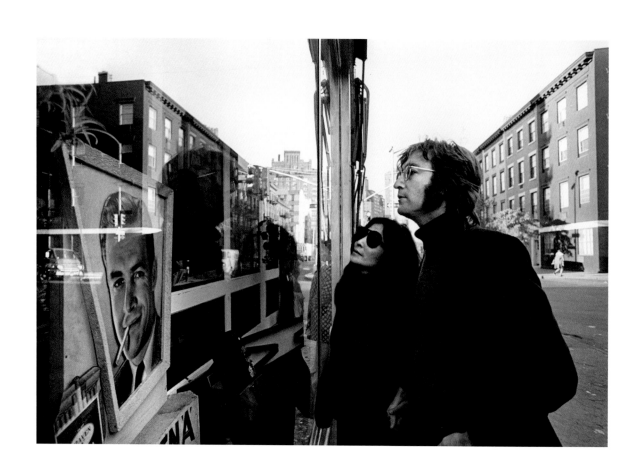

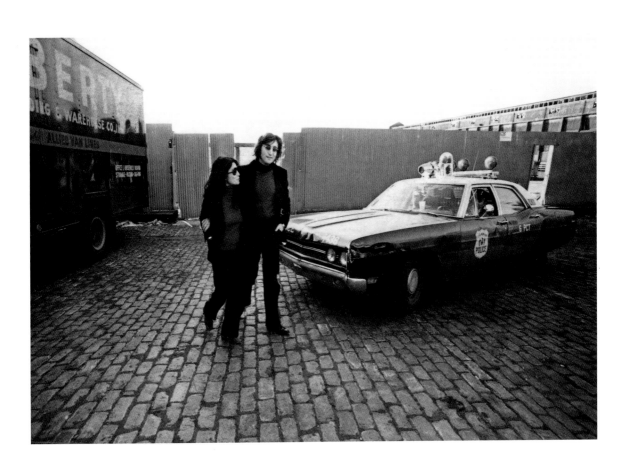

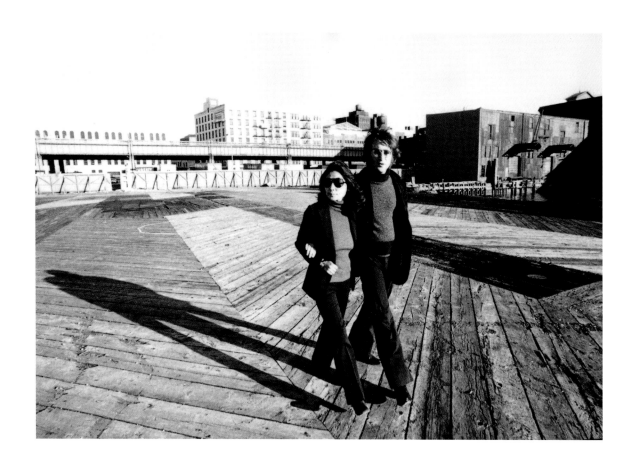

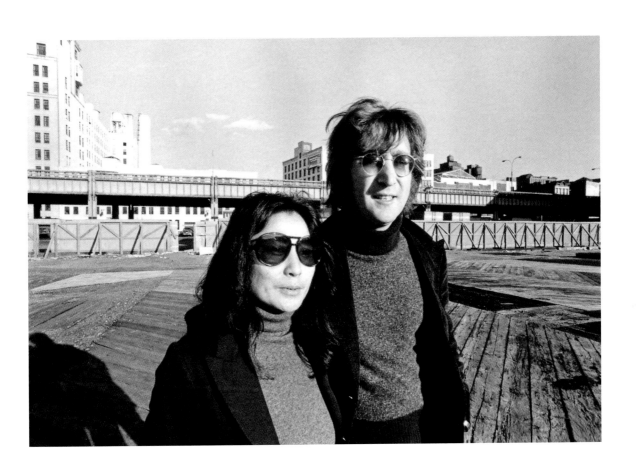

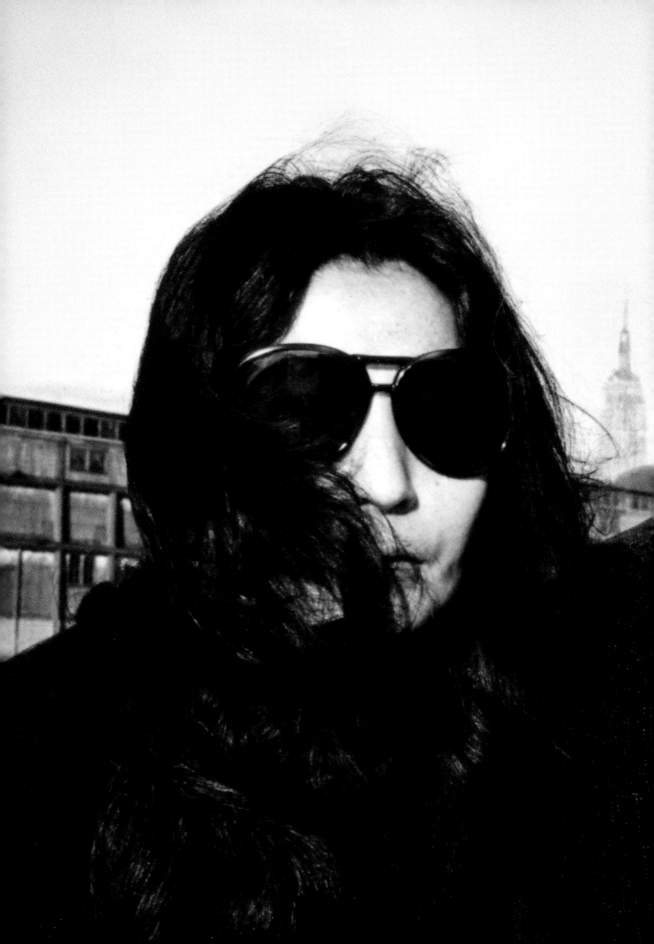

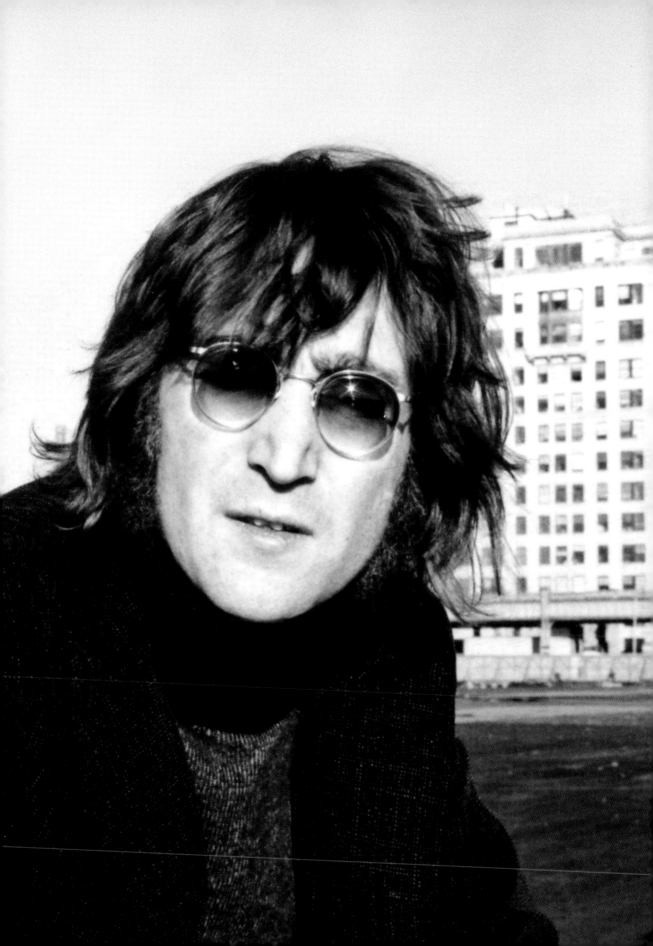

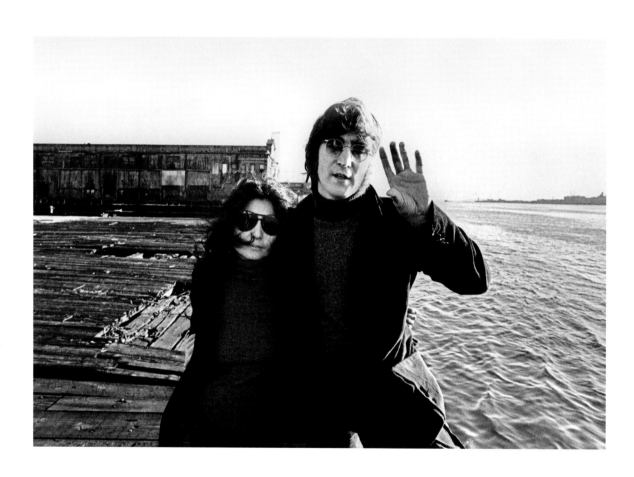

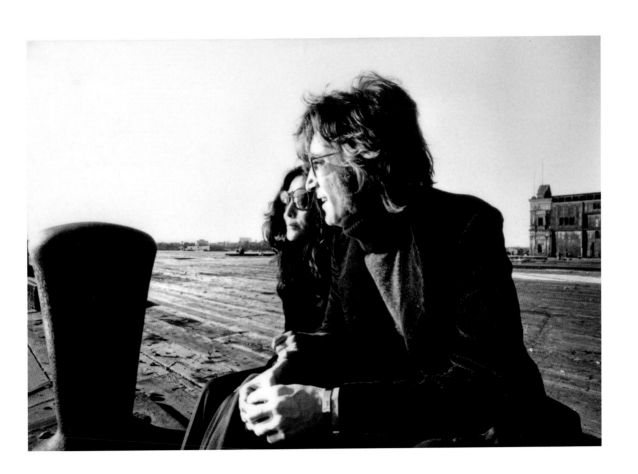

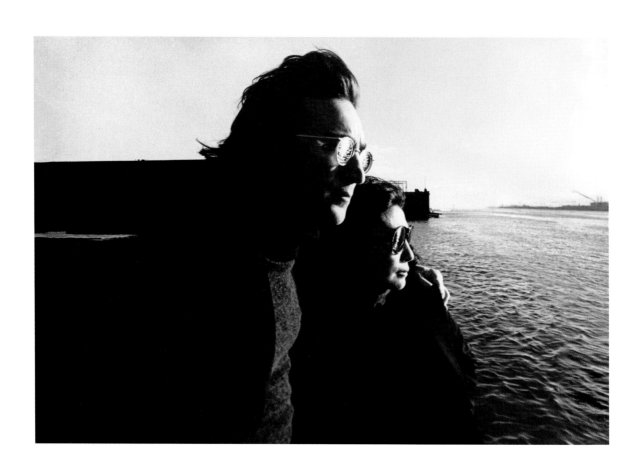

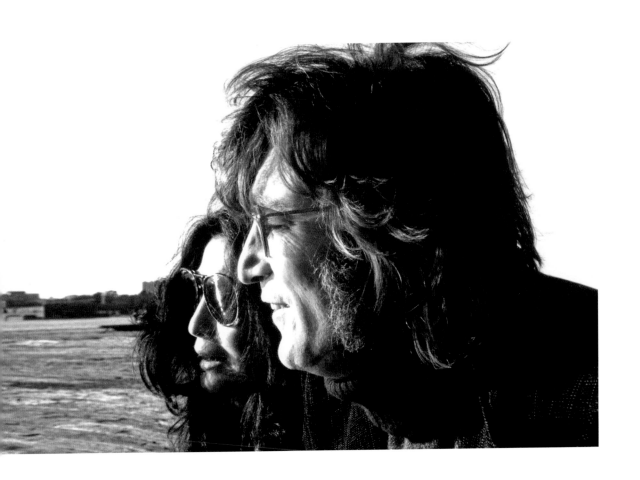

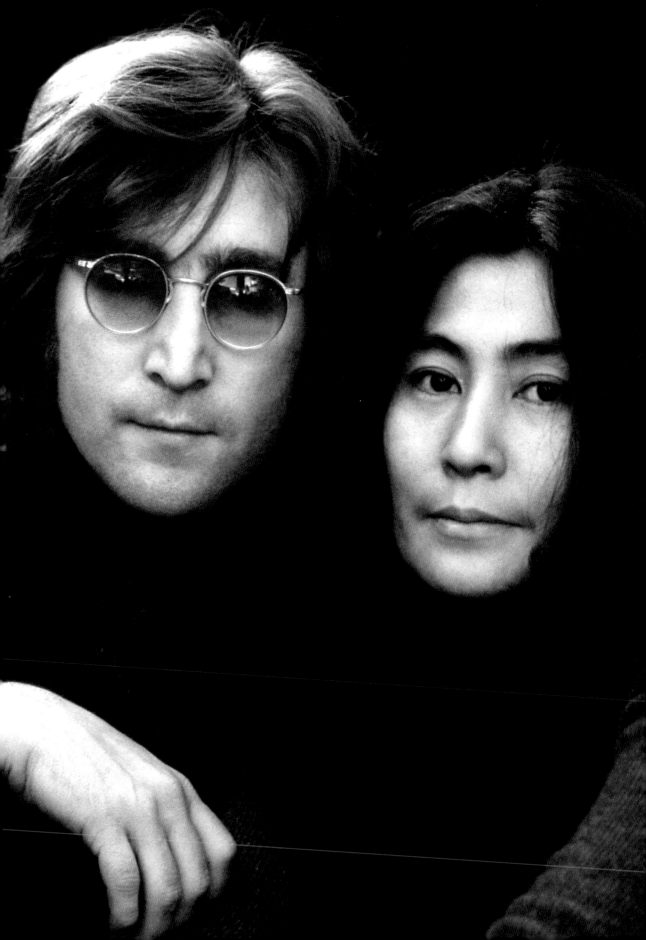

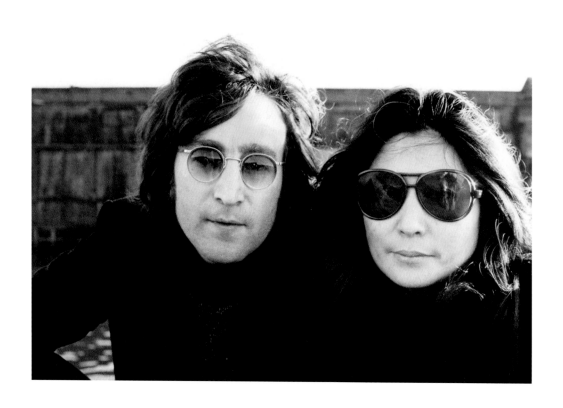

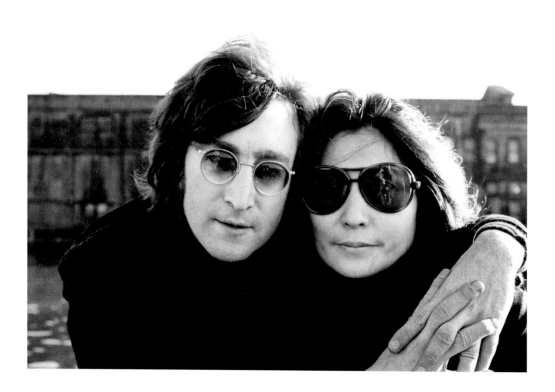

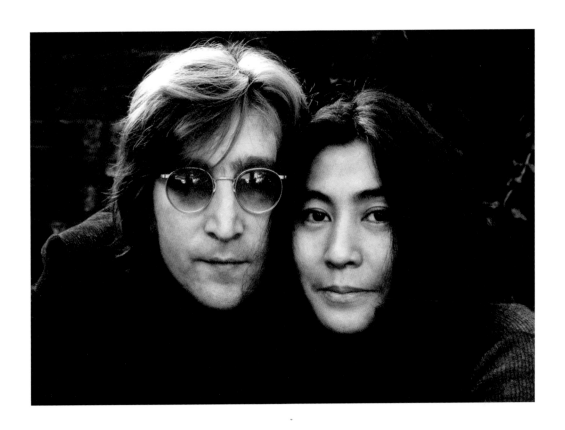

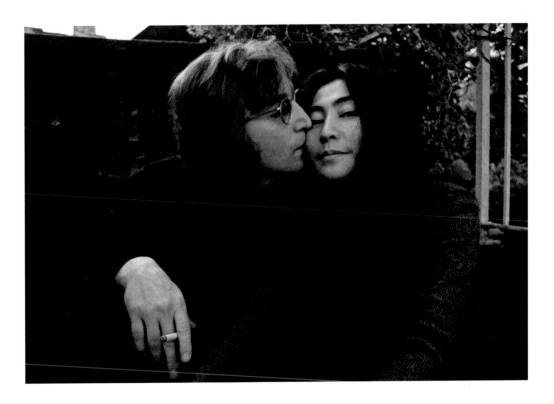

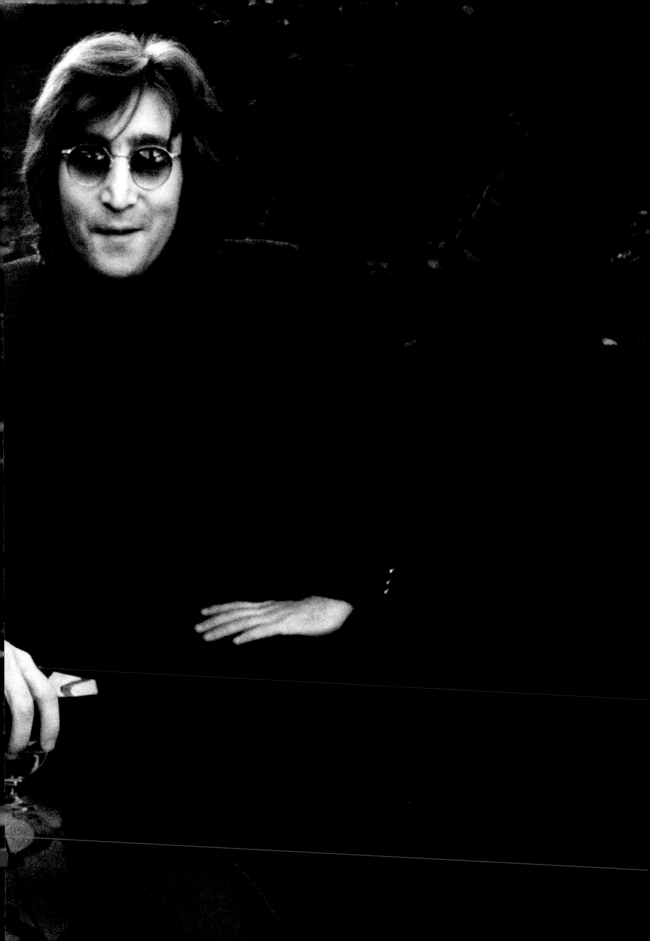

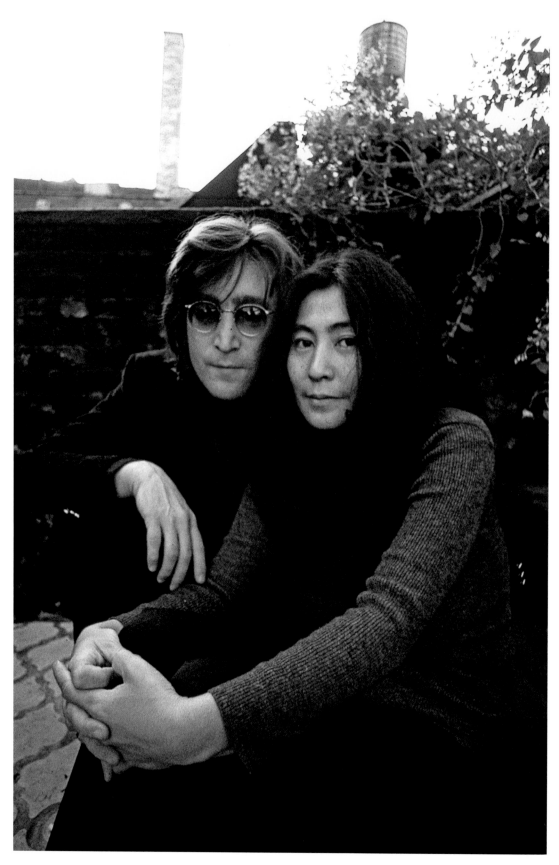

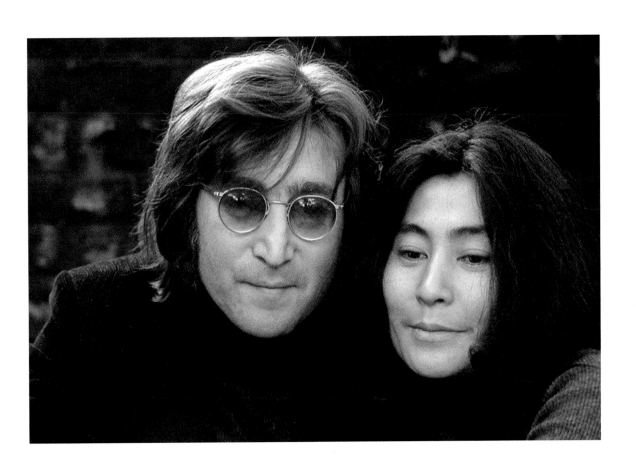

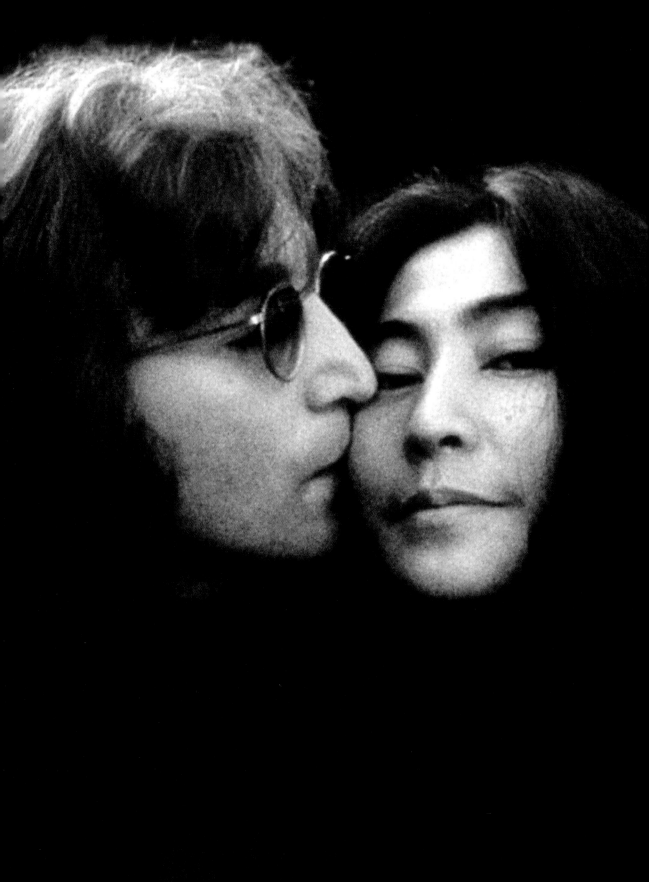

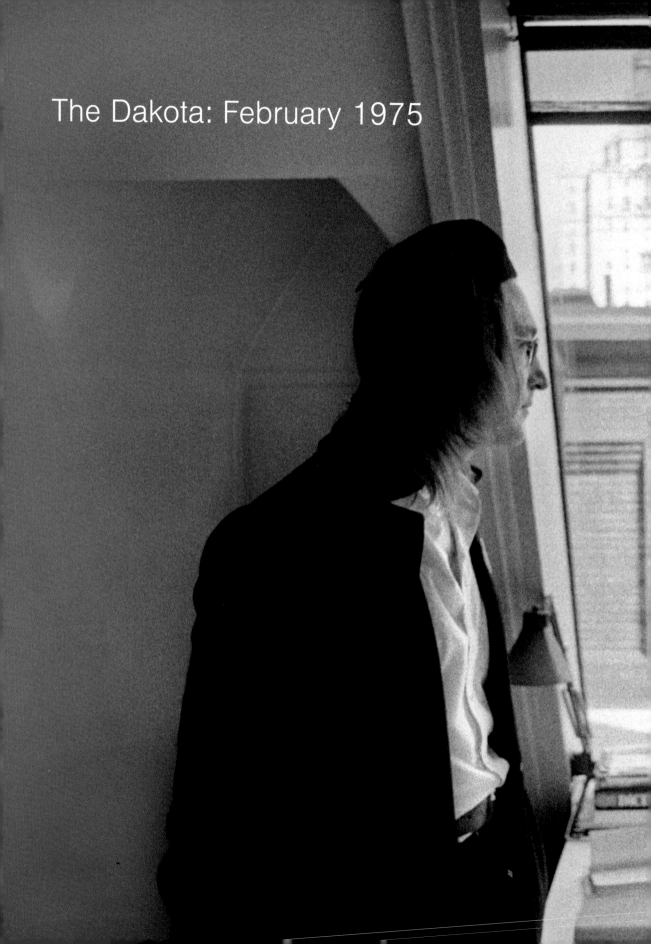

The Dakota: February 1975

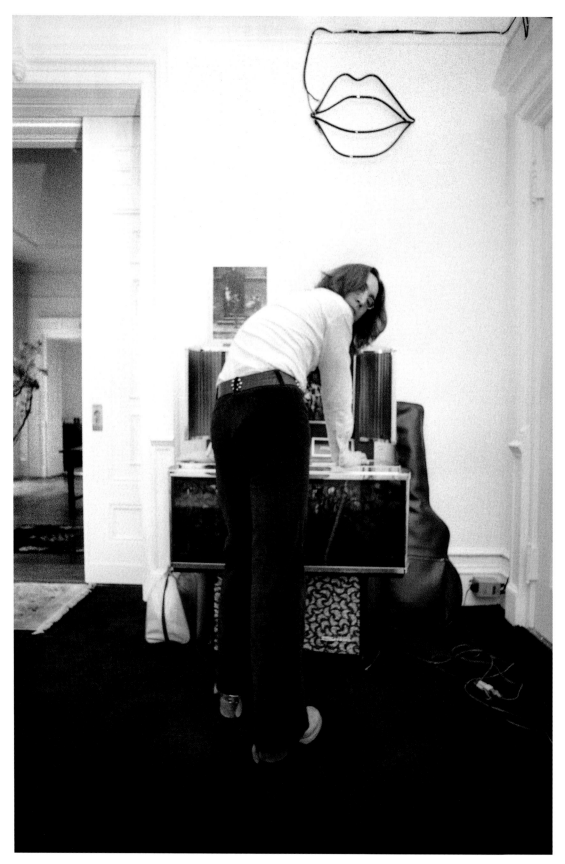

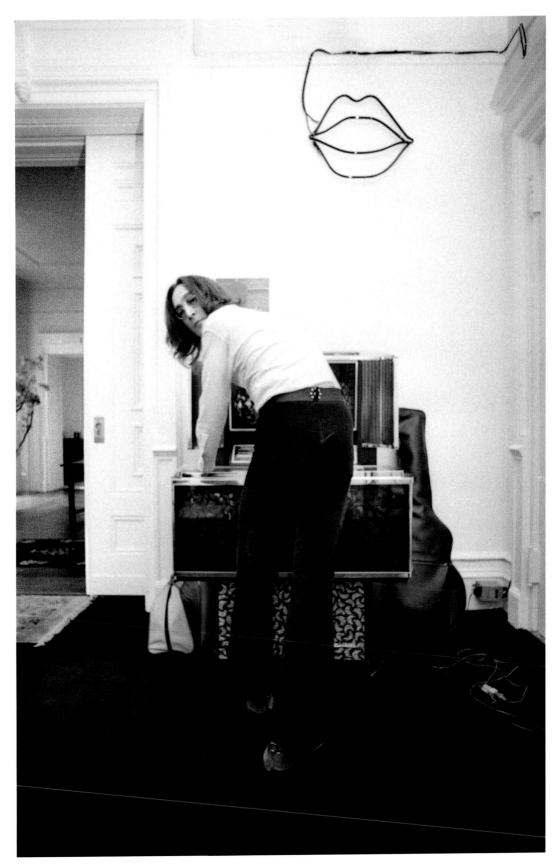

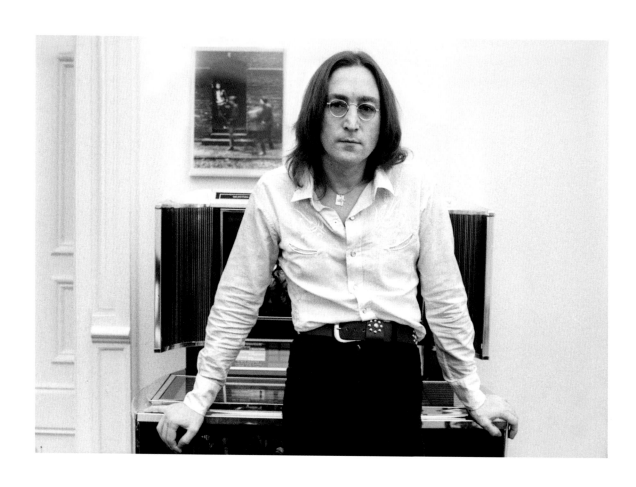

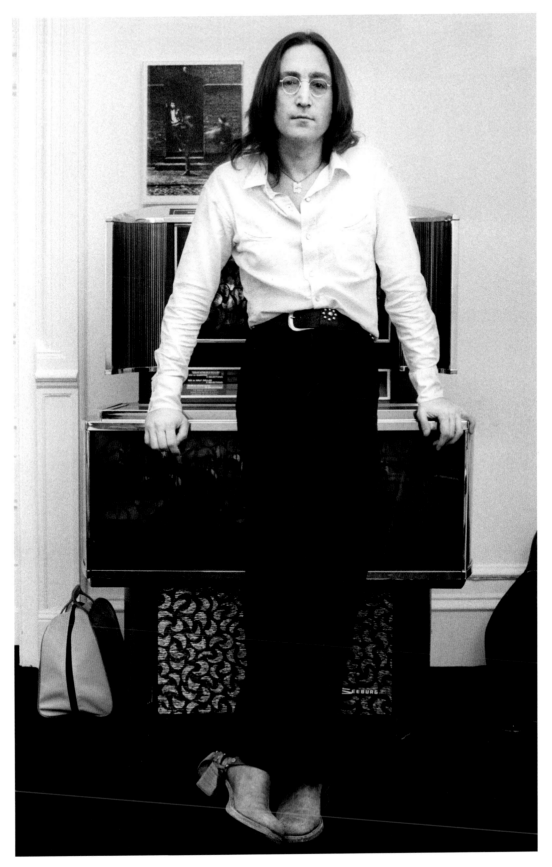

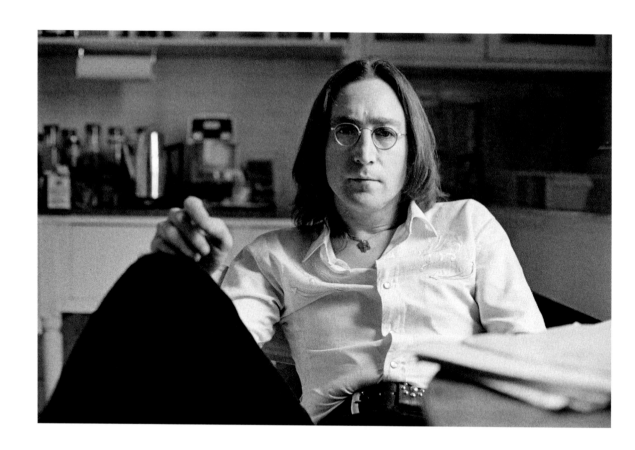

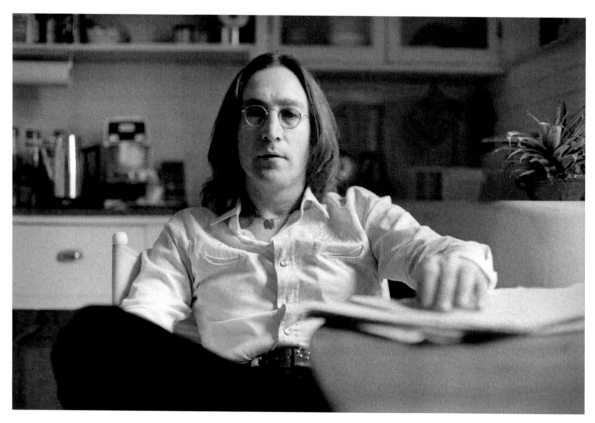

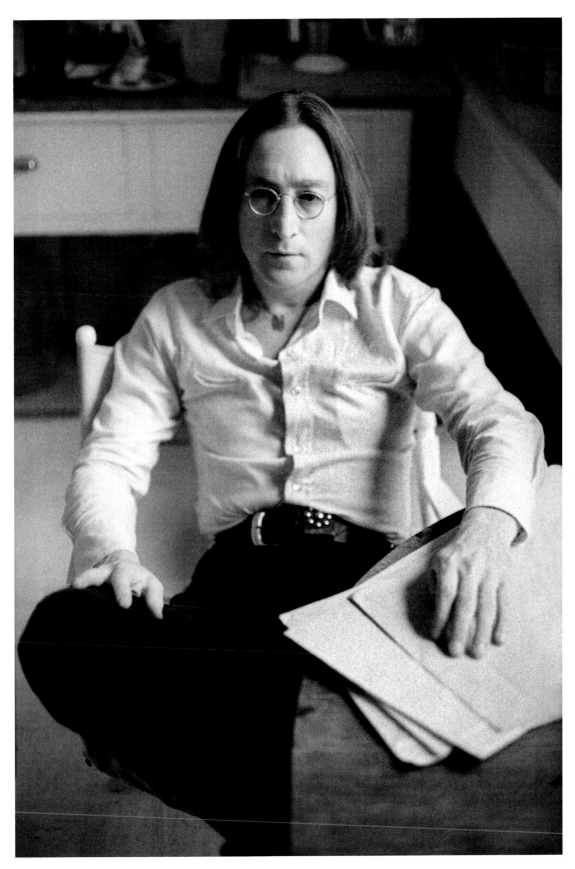

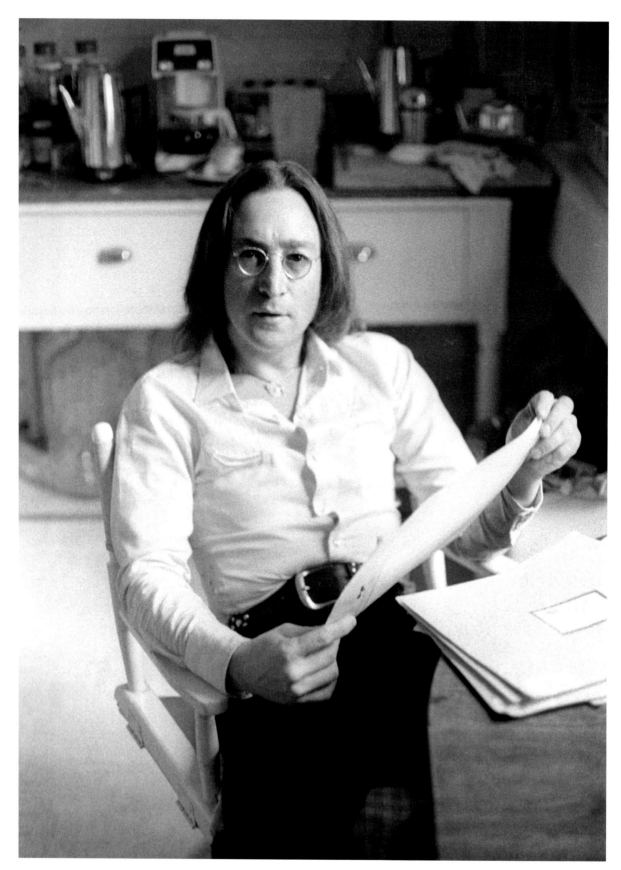

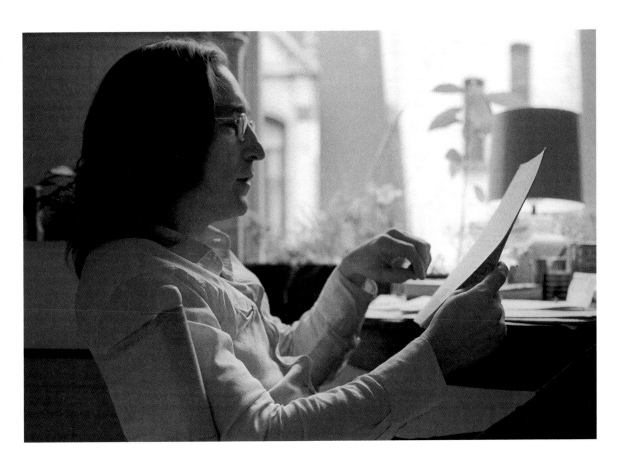

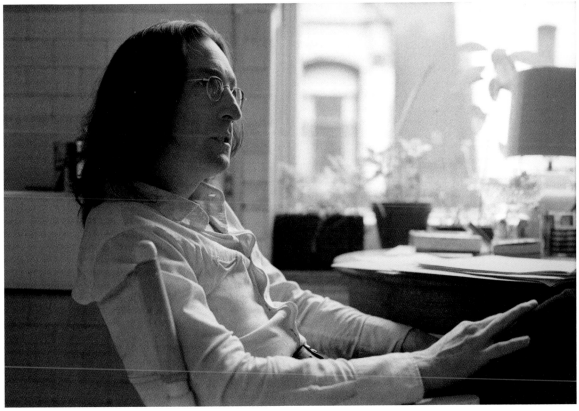

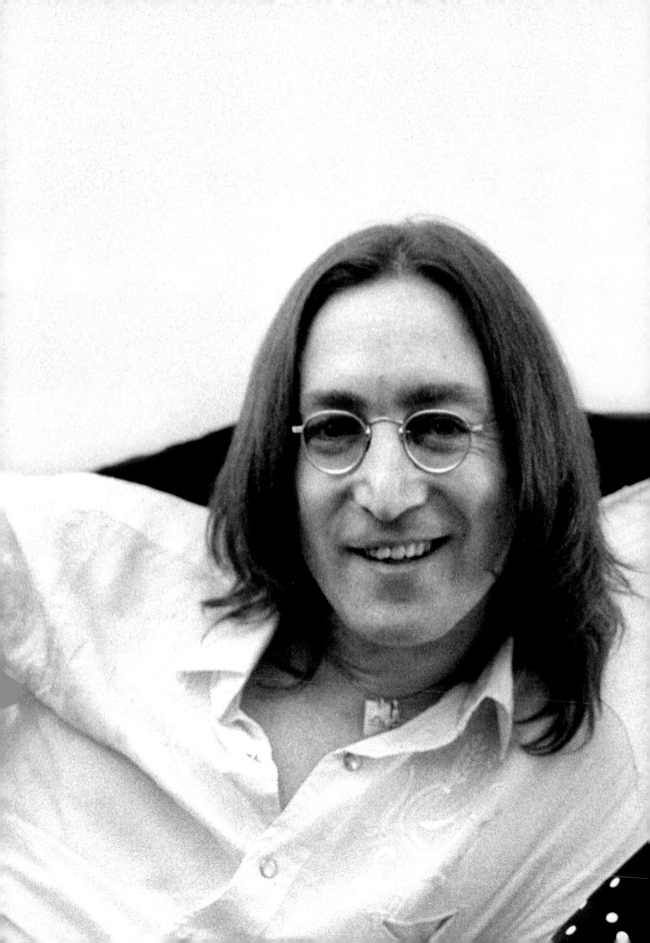

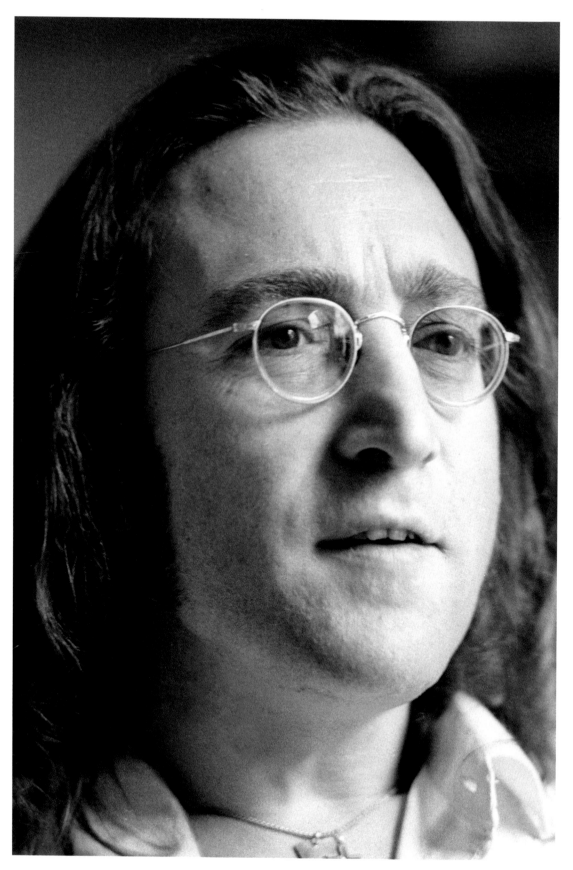

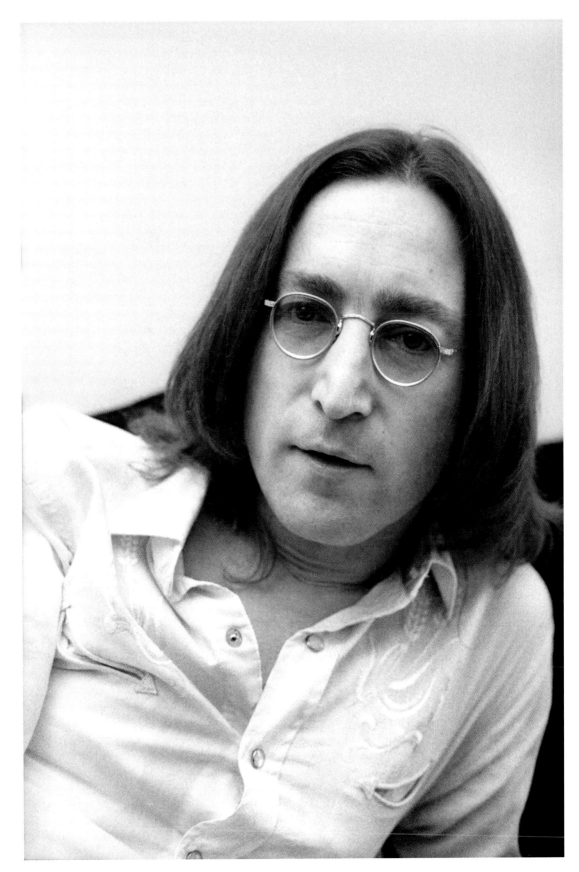

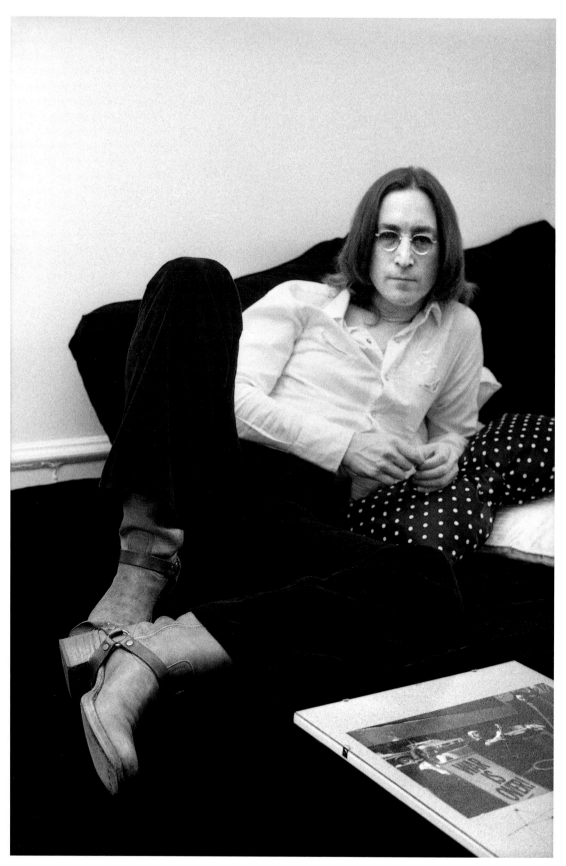

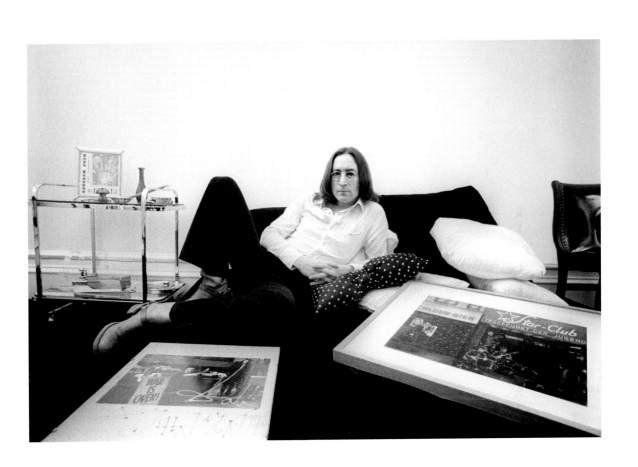

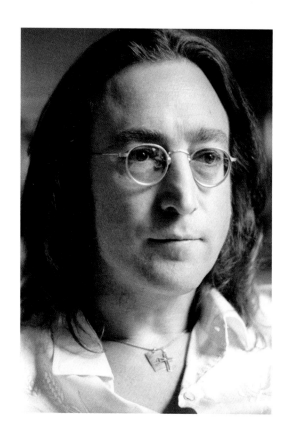
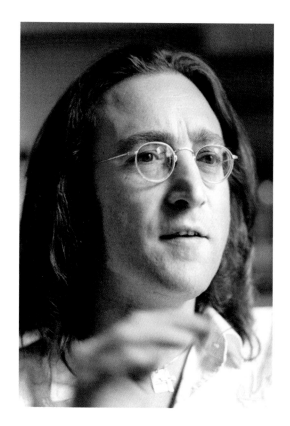
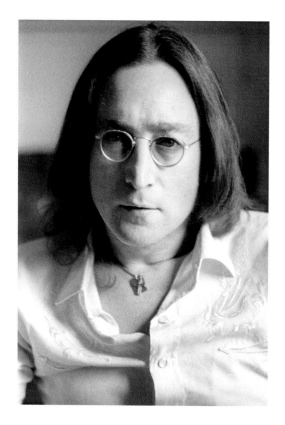
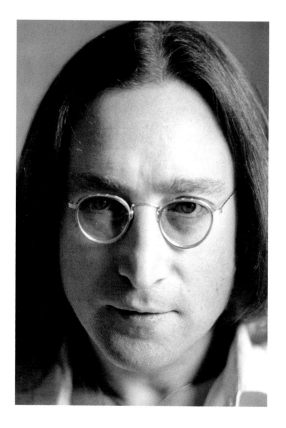

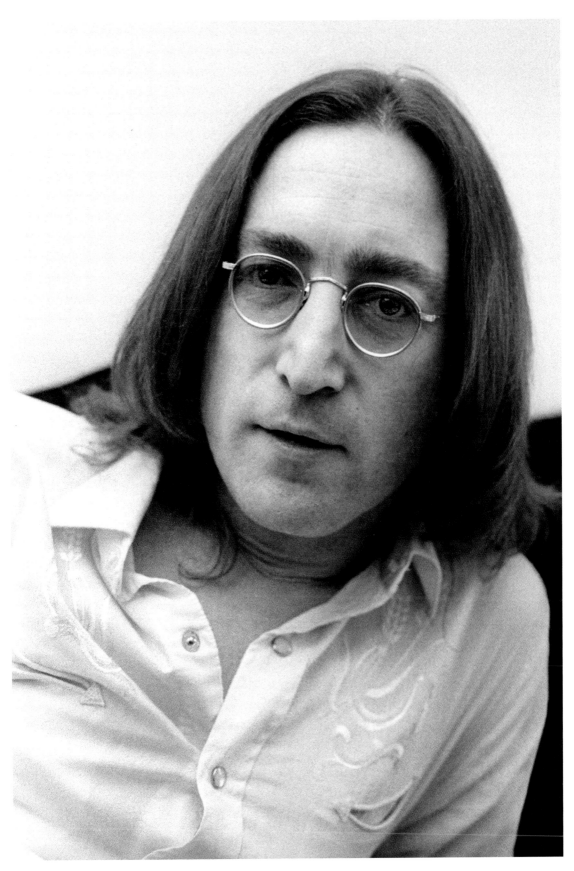

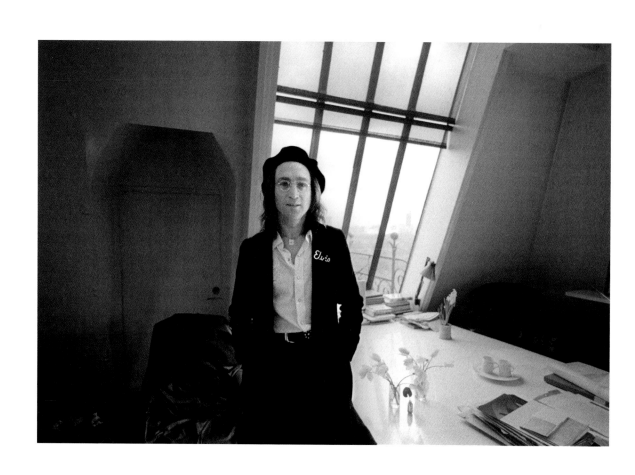

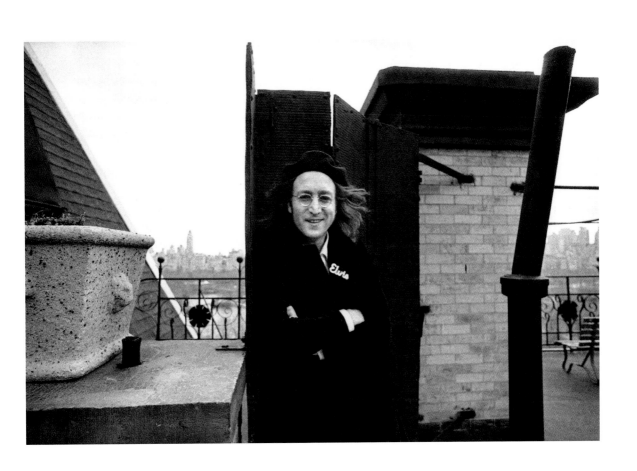

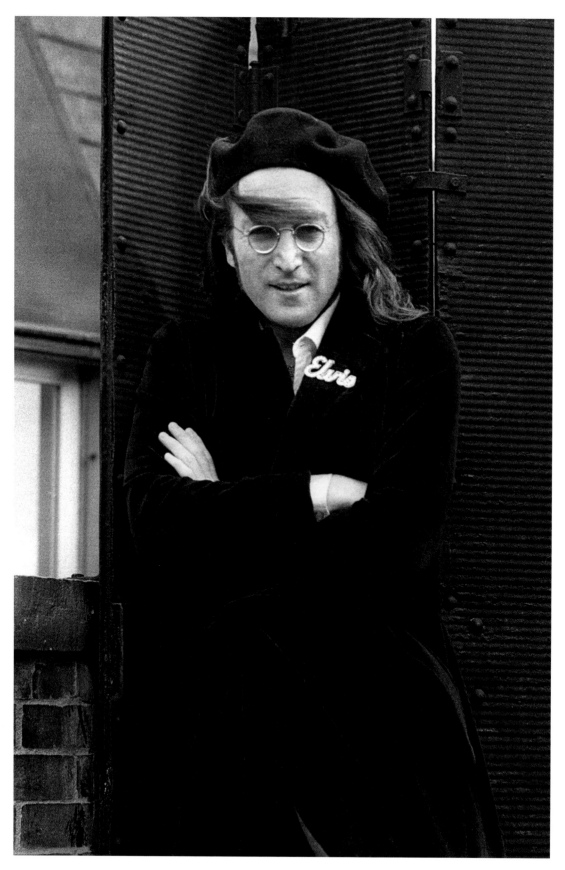

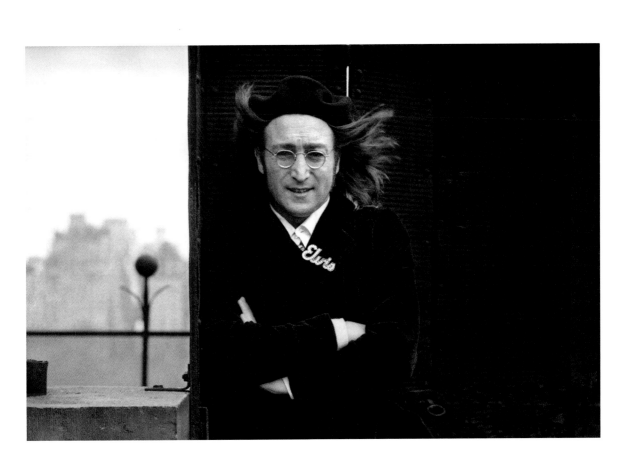

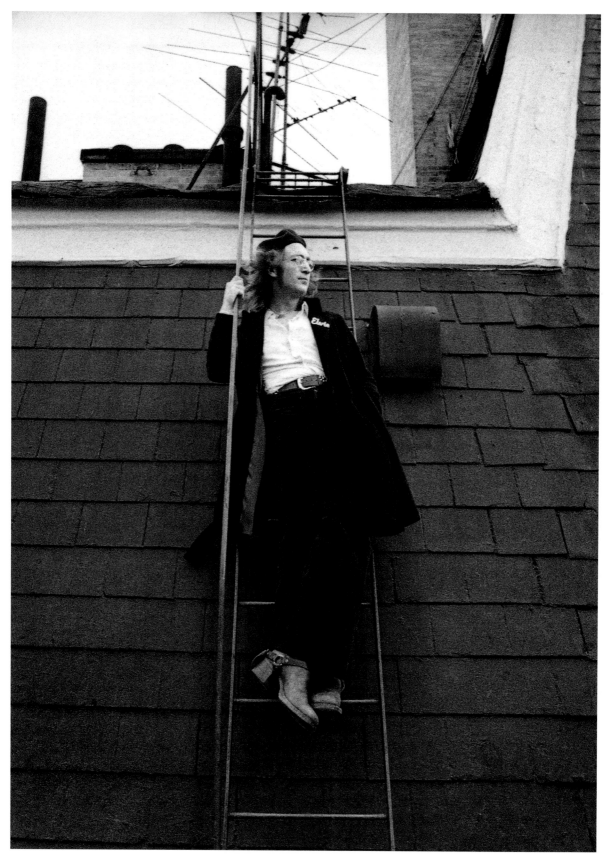

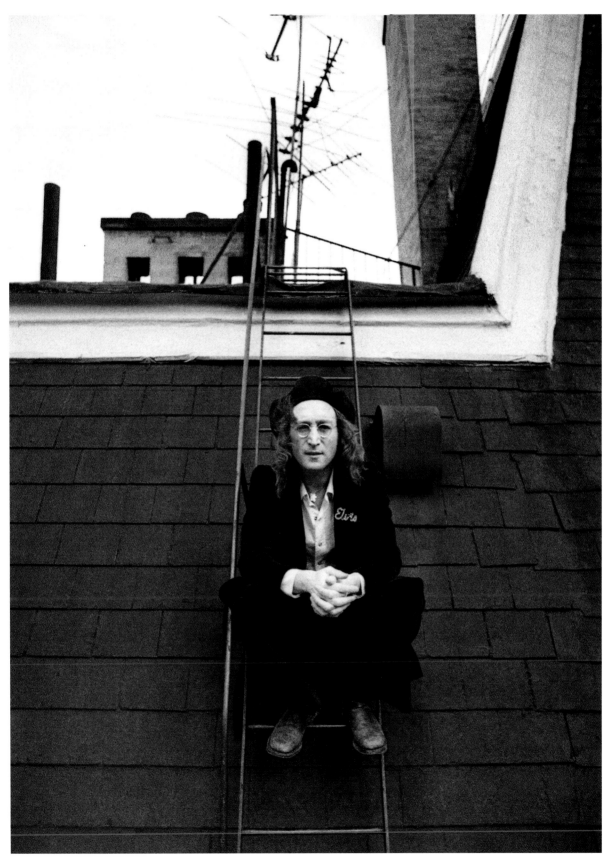

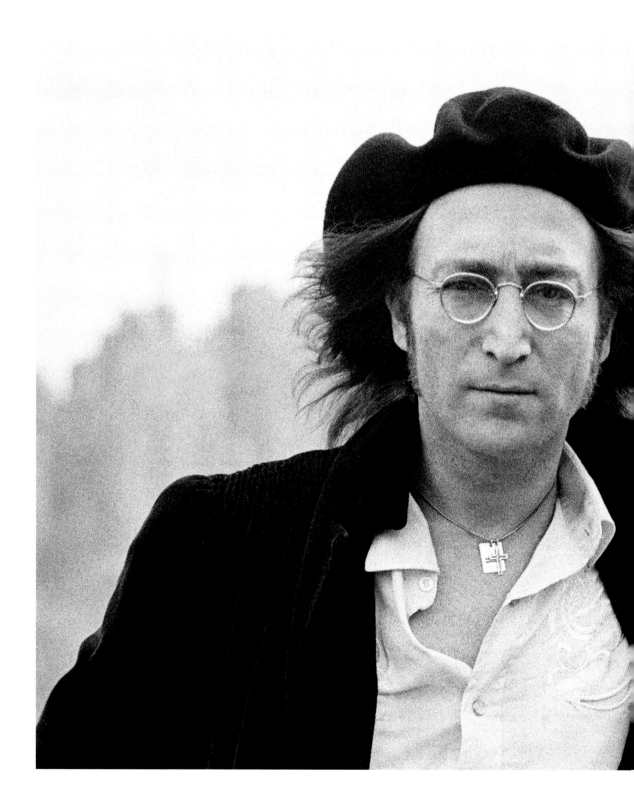

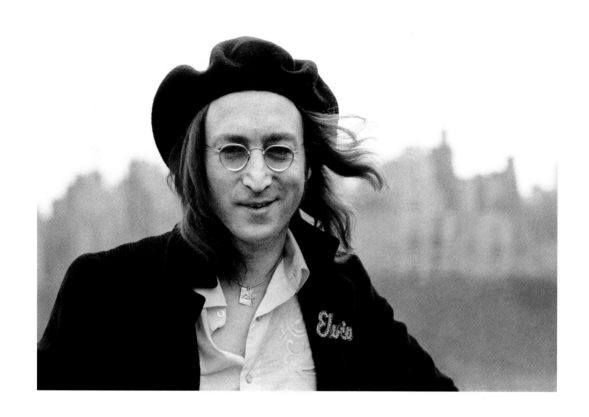

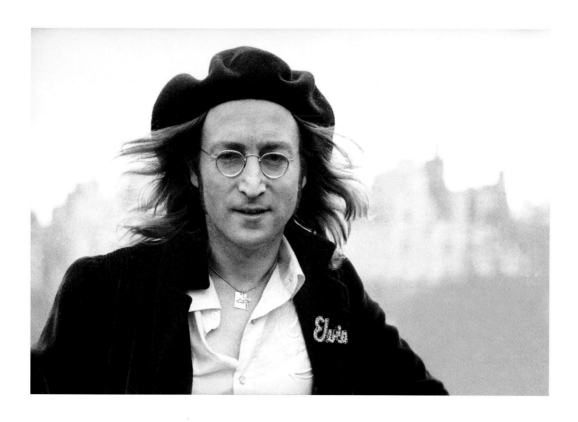

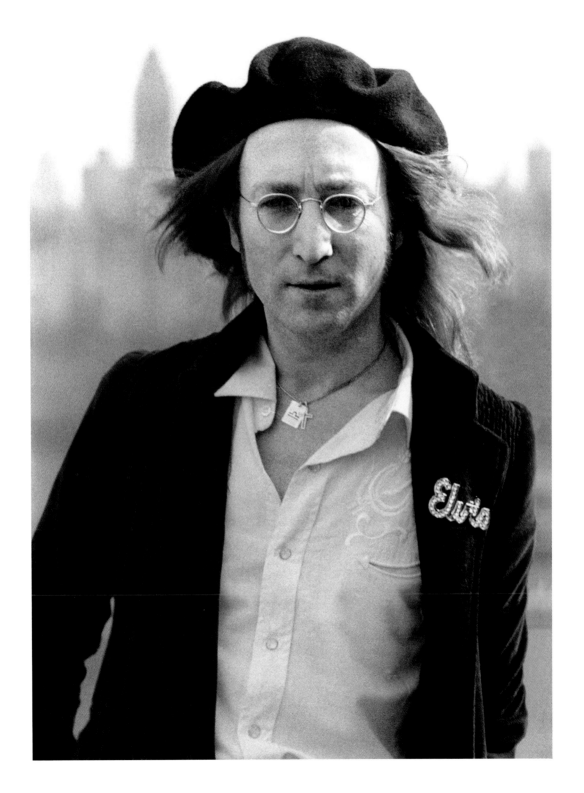

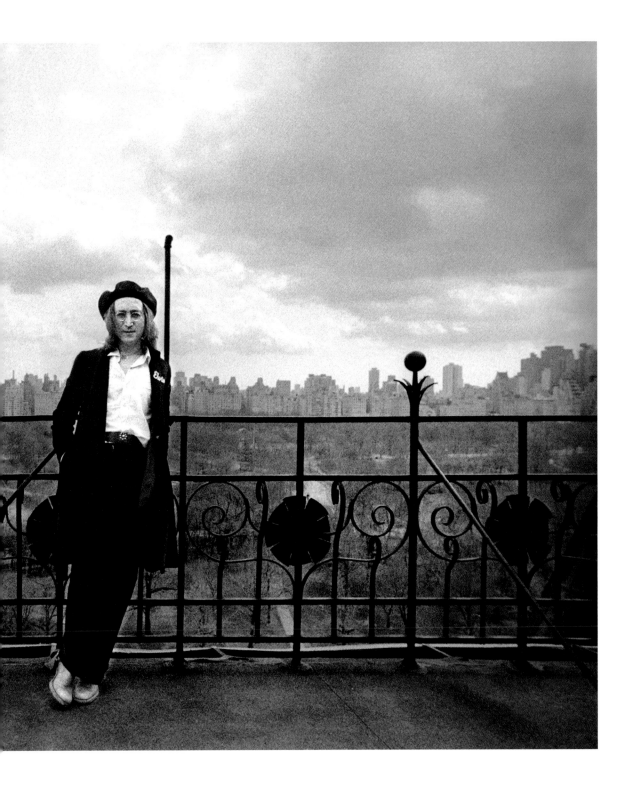

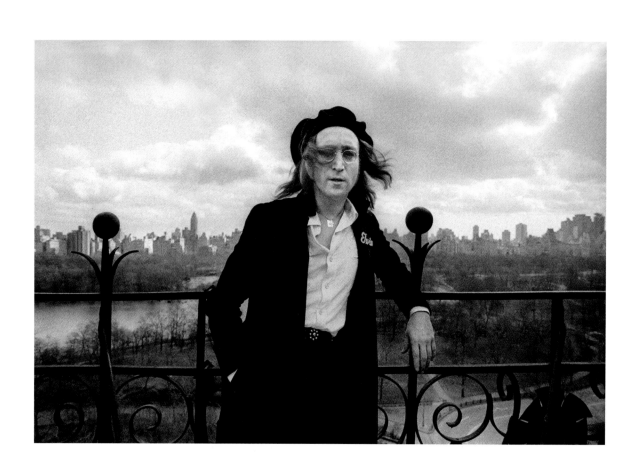

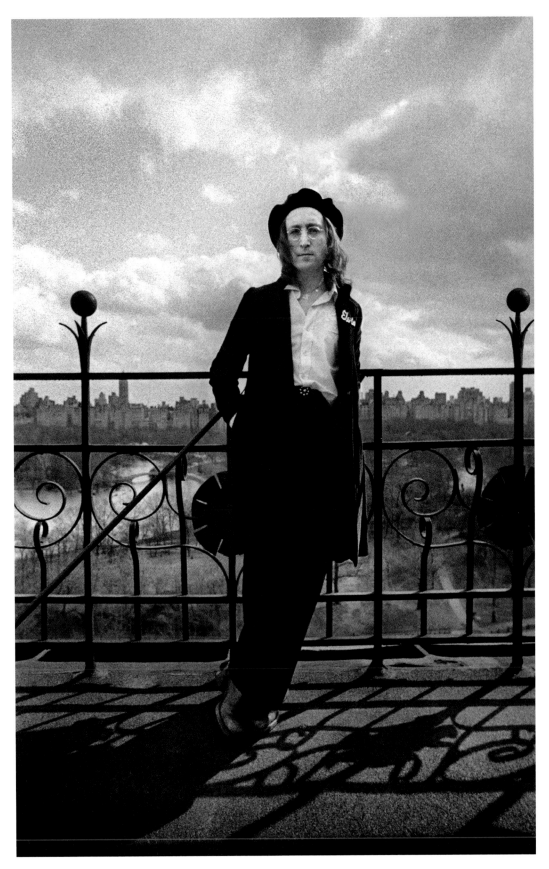

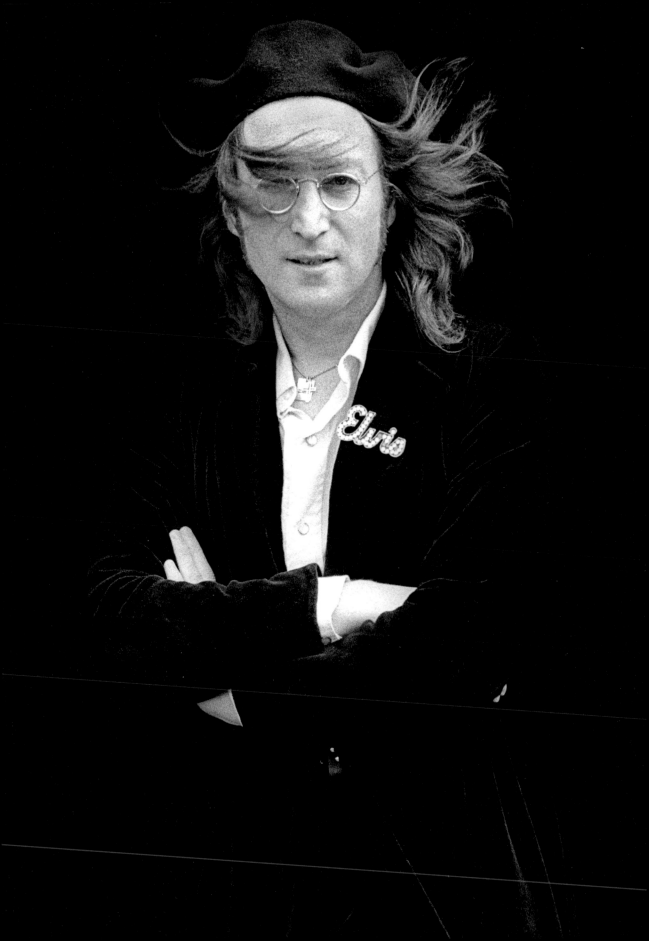

For Brian Hamill: Recollections
David Palmer

Two out of the first three times I met Brian Hamill there was *mishegas* involved. Either someone was threatening to throw a punch or someone actually did. If I'd been paying attention, I would've known right then that Brian and I would have an ongoing friendship that would ebb and flow for the next 55 years. Our first meeting was at Summit High School in Summit, New Jersey in December of 1965. My band, The Myddle Class, was being managed by the pop music columnist for the *New York Post*, Al Aronowitz. One of Al's colleagues on the *Post* was Pete Hamill, and one of Pete's brothers was an aspiring young photographer, Brian Hamill. One of Al's other groups on the bill that night was a New York outfit called The Velvet Underground. And on December 11, 1965, The Velvet Underground opened for The Myddle Class and all sorts of hilarity ensued.

The Velvets wore their all-black heroin-chic outfits and we wore our Rolling Stones facsimile gear and no one in that basically all-white teenage/parent-chaperoned audience knew what to make of any of it. And Brian was there along with a couple of his buddies. Just before we went on, Al told Brian that he thought his new tape recorder had been stolen. So Brian rounded up the unusual suspects (The Velvets' crew) and told them if the tape recorder wasn't returned in twenty minutes, some serious repercussions would occur. Al's tape recorder miraculously reappeared and we

went on with the show. I learned that night Brian evidently had a way with words and could be very persuasive.

The second time I met Brian was at Al's house in Berkeley Heights, New Jersey. It didn't take me long to realize he was a tough, smart Brooklyn kid and I was a less tough almost as smart rock and roll wannabe, and that the common ground between us was ambition and intellectual curiosity. Our third encounter was in Kingston, New York. We were playing a show there in support of our just-released first single. Apparently, the local townie boys took exception to the fact that their girlfriends were more interested in us than they were in their boyfriends, and this time punches WERE thrown, with Brian and his Brooklyn posse stepping in to defend us. This was a good thing since only two of us in the band knew anything about fighting and we would've gotten our collective asses handed to us.

Five years and two bands later, Brian came back in my life. This time he had his camera in hand and shot my band's individual portraits as well as our album cover. And there's something about this cat that once again draws me to him. He makes no bones about the fact that he's intrigued by celebrity and show business but his portraits go deeper than that. His captures look effortless but I know, as an artist, how much efforting is

going on to create that look. Not long after that shoot, Brian went off to Rome to begin his career as a movie-set photographer and another band I'm with ends up on the rock and roll scrapheap.

In 1972, I came to Los Angeles to join Steely Dan and Brian went to Northern Ireland to document the Troubles. I recall seeing those pictures without knowing who the photographer was and being struck by their gravity and weight. They told the story in a way that images should; you didn't even need text to get the full impact. And when I found out who the shooter was, I felt distinct pride in the fact that both of us were going on to do something with our talent and our lives. During that period in LA, Brian would track me down from time to time and come by my house in the Hollywood Hills and he'd usually have an up-and-coming actress or actor in tow. More often than not, a beautiful actress. And I'd look forward to his visits because it meant there would be a party and a night of drinking. By this time, I was well on my way to becoming a full-blown alcoholic. Hard drinking was in the rear-view mirror. And then we lost contact again. It was in 1975, on assignment for *Rolling Stone*, that Brian shot those iconic portraits of John Lennon at the Dakota. And, once again, I was made aware of what a talent he was.

Through a series of what I can only describe as divine serendipitous events, and unbeknownst to me, in 1983 Brian and I both quit drinking within a couple of months of each other. Me because booze and drugs were killing me; Brian because it was interfering with his life and profession. In 2006, we reconnected at a show he was doing in LA. By this time, my rock and roll expiration date had passed and I had picked up a camera and was beginning to develop a style of shooting. By coincidence, my friend and mentor was Owen Roizman, the oft Oscar-nominated cinematographer on *The French Connection*, *The Exorcist* and a slew of others. Owen had worked with Brian and had nothing but high praise for his skills and professionalism, and so we both went to his show... it was a terrific reunion.

I received the galleys of Brian's book the other day and all I can say is: "It's about time". Brian and I are both more than survivors. He's been through virulent cancer and so far I've beaten the sad fate of most alcoholics. But we still create and function and live our lives looking forward to the next adventure. So thank you Brian for your encouragement and friendship over the decades, and thanks for the privilege of allowing me to honor your accomplishments. I was going to say, if we'd known we were going to be around this long, we would've taken better care of ourselves... but why end this with a boldface lie? Carry on my friend.

Acknowledgements

Firstly, to my remaining brothers, Johnny, Denis and Pete, and to my beautiful sister, Kathleen.

RIP to my brothers Tom and Joe. Love you all a lot and thanks so much for continued family laughter and loyalty.

To: Team ACC for all of your effort in making this book come to life. Particularly to James Smith for his alert eye, and for reaching out to me. He and his own sidekick Andrew Whittaker were both brilliant with ideas and were never resistant to mine. Thanks for giving my work a lovely home. Amen. Another special shout-out to add to Team ACC goes to the designer, Steve Farrow. His elements of design were truly a gift to my images and the overall handsome look of the book.

To: Andy Cohen, who does terrific photography on a daily basis (andrewcohenphotography.com) and has a great discerning eye to help me edit my images and maintain my website, and is a whiz with anything technical. He is not only my colleague, but my friend.

And lastly, but very importantly, to GR (George Ryan) and Rondo (Ronald Moore). We went to Catholic grammar school together, and met in the first grade at five years old. They are still my loyal, best friends forever.

FSC
www.fsc.org
MIX
Paper from
responsible sources
FSC® C057358

Printed in Slovenia by DZS
for ACC Art Books Ltd., Woodbridge, Suffolk, England

www.accartbooks.com

Author photograph on page 24 by Cara Hamill.

ACC
ART
BOOKS